MAR 1 2 2012

W9-CCV-533

REC'D

WITHDRAWN

OPEN STUDIOS

with **Lotta** Jansdotter

TWENTY-FOUR ARTISTS' SPACES

Lotta Jansdotter

Photographs by Jenny Hallengren

CHRONICLE BOOKS

SAN FRANCISCO

Copyright © 2011 by Lotta Jansdotter.
Photographs copyright © 2011 by Jenny Hallengren.
All rights reserved.
No part of this book may be reproduced in any form without written permission from the publisher.

Library of Congress Cataloging-in-Publication Data:

Jansdotter, Lotta.
 Open studios with Lotta Jansdotter : Twenty-four artists' spaces / Lotta Jansdotter ;
photographs by Jenny Hallengren.
 p. cm.
 ISBN 978-0-8118-7312-3 (pbk.)
 1. Artists' studios. 2. Workshops. 3. Artists—Interviews.
4. Artisans—Interviews. I. Hallengren, Jenny. II. Title.
N8520.J36 2011
702.8—dc22
2010013581

Manufactured in China
Designed by Ayako Akazawa

10 9 8 7 6 5 4 3 2 1

Chronicle Books LLC
680 Second Street
San Francisco, California 94107
www.chroniclebooks.com

Contents

Introduction

For me, as a designer, there are few activities more fascinating than peeking into other creative spaces. I love to learn about what other people do in their spaces, to see their processes and their tools, and to get tips and inspiration on how to organize it all (or how not to!).

When I first moved to Santa Cruz, California, from Sweden in 1991, I was a novice designer, trying to figure out my skills, interests, and passions as a creative person. I was searching for my "calling."

I was delighted to discover the town's annual self-guided "open studios" tour, when artists and designers around town open their doors to the public and share what they do. Some of the artists are professionals, but many of them are amateurs. For some, "studio" means a high-tech loft with expensive equipment; for others, it means their

kitchen table where they sit and sketch; and for still others, it means a space shared with other artists.

Before then, I had never heard of such an event and was simply amazed by the whole thing. I found it inspiring to see how other creative people lived and worked. This experience had a big impact on me and encouraged me to become a designer myself.

Now, many years later, I have discovered that these events take place in cities and towns all over the United States (I still haven't heard of anything like this in Sweden, though). My new hometown, Brooklyn, has similar events, too, and of course I go as often as I can.

One reason why I love what I do is that I enjoy the creative process of it: the making of things, the

planning, the dreaming and sourcing, the sewing, the drawing, and the paper cutting. I even love the fretting and the constant cycle of cleaning up and organizing. (I don't like the process of doing my taxes, though.) To me, the process is even more important than the result. Because of this, it is only natural, I think, that we humans are curious about other people's processes. In the profiles of the twenty-four artists here, I've tried to include details on their creative process.

I am fortunate enough to have a global network of artists and designers, many of whom live in three of my favorite cities: Brooklyn, Stockholm, and Tokyo. Thanks to my work as a designer, I have met these inspiring people at trade shows, events, cocktail parties, and dinners—even in the park. I grew up in Stockholm and have very close connections to that city and its creative community. I also have ties in Tokyo, which I have visited numerous times and where I have been invited into so many interesting homes and studios. Those visits have been incredibly influential for me. Now Brooklyn, New York, is my home, and here there are more talented and fascinating people than I can keep track of: it is a mecca of creativity.

I hope you will enjoy seeing these spaces and reading the many tips and ideas about how to shape, decorate, and organize your own studio space. More important, I hope that you feel encouraged to simply do what you love to do—to start creating your work in whatever castle or nook feels right for you.

Happy peeking!
Lotta

brooklyn

 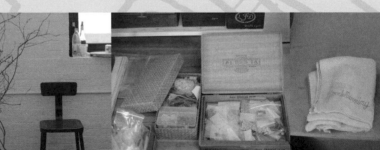

I moved to Brooklyn four years ago. I was drawn to the borough for the same reasons that many other people are drawn there: a slightly slower pace (and cheaper rents) than in Manhattan; an abundance of great cafés, restaurants, and shops; and a rich history and culture.

Young artists and designers started to relocate to Brooklyn in the mid-1990s, on the hunt for more space and affordable rents. Back then, parts of Brooklyn were not entirely safe, but that has changed over time as more and more people have moved in and started to build new communities.

Today, Brooklyn is as bustling and vibrant as ever. There is always something to do, see, or eat: events, workshops, concerts, people watching, and terrific food. It is a culturally diverse place that constantly inspires me. And it's easy to meet creative professionals as well as people who create as a hobby.

In the next few pages, I will take you to visit some of my good friends and creative counterparts. I could fill several volumes with Brooklyn studios alone—it was challenging to pick just eight! In the end, I chose these studios because the artists who work in them come from very different backgrounds and work in a range of media. I hope you will be as smitten with the creative side of Brooklyn as I am.

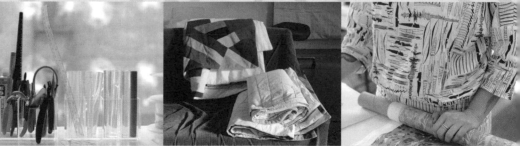

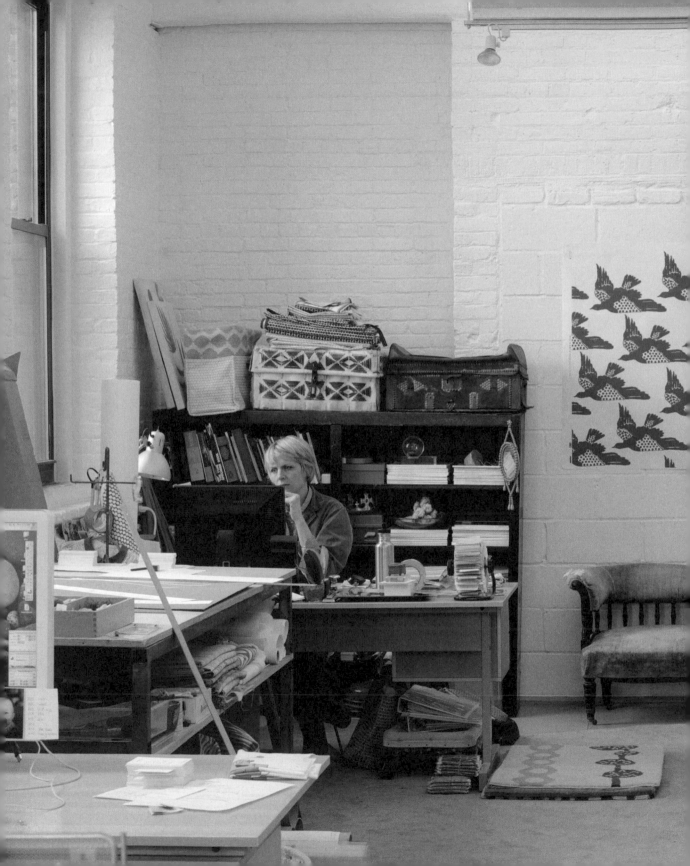

hable
construction

Susan and Katharine Hable

Textile designers and owners of Hable Construction

Studio size: 1,650 square feet (153 square meters)

Time in studio: Five months

Susan and Katharine, the friendly and cheerful sisters behind Hable Construction, recently relocated their textile business from a basement space in Manhattan to Brooklyn—and, boy, did they ever upgrade. Their new studio, located in an old brick canning factory in the Gowanus neighborhood, is spacious and flooded with natural light.

When I learned that Hable Construction had moved into the studio right around the corner from me, I was thrilled. I have long been an admirer of their textiles; I've chatted with Susan and Katharine at trade shows and attended their openings in Manhattan. I decided to pay them a visit because I was interested in checking out the new space and also figured it was a perfect opportunity to welcome them to the neighborhood.

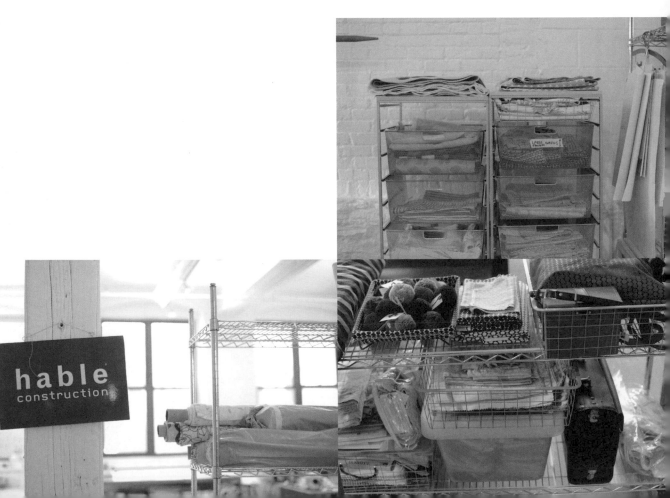

Hable Construction creates and produces hand-screened textile products like fabric, totes, and pillows, among other things. They started the company in 1999 in San Francisco and moved their business to New York a few years later. The studio space is where Susan develops the designs and Katharine oversees the business end, working alongside three other staff members, who handle things like light production, cutting, and sampling.

When designing their new space, the sisters combined modern furniture and industrial pieces with worn and loved antiques. The result: a very functional and personalized work environment.

When Jenny (this book's photographer, who accompanied me to all the studios) and I knocked on Hable Construction's door, we were greeted with strong, hot coffee and big smiles.

The Hable ladies use simple wire shelving to store samples, swatches, fabric bolts, and supplies. The taller units also function to section off the big open studio into smaller work spaces. The shelves have cast-iron wheels so that the designers can easily move them around the space. Very clever. This worktable (below) is wide enough to hold fabric bolts, with equal space for storage underneath.

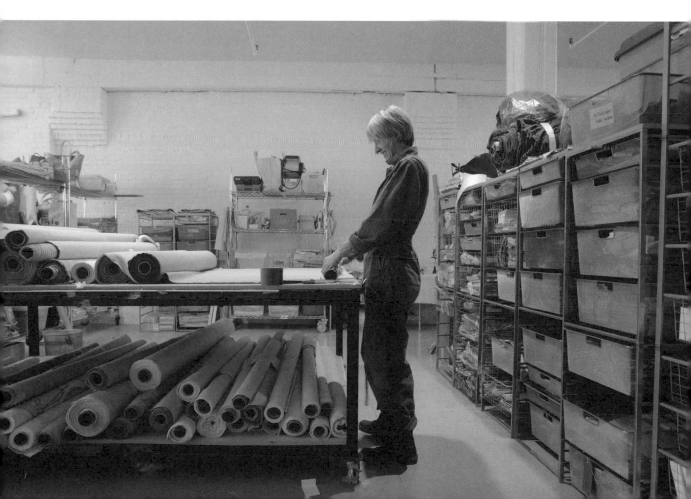

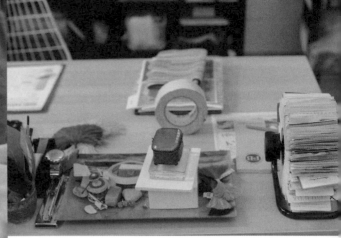

Above is a close-up of Susan's desk. Her big Rolodex is rather impressive; imagine all of the fun contacts she has made through the years. This workstation below is where the Hable ladies plan and cut out patterns.

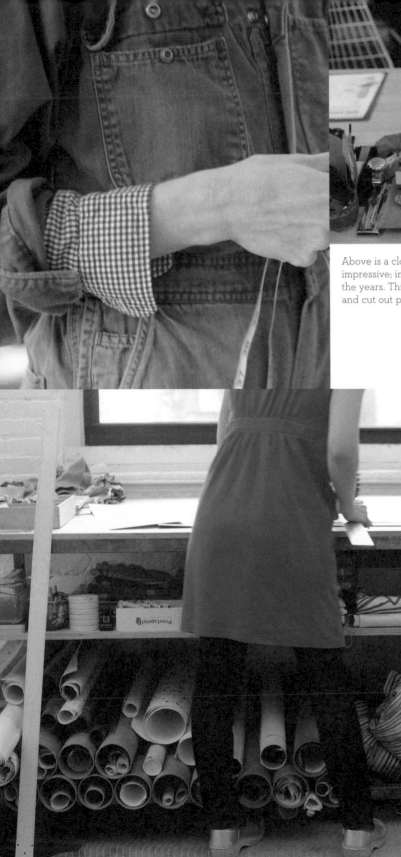

Along one wall the Hable sisters use a basic IKEA shelving unit filled with all the paperwork they need to run their business. I love how they updated boring plastic binders by covering them in Hable's stylish fabric (above). Susan let us peek at some of her sketches and drawings (below). So pretty! She keeps them in a white flat metal file case.

Here is an antique wooden cabinet filled with interior design, fashion, and craft magazines—an important source of inspiration for any designer. The storage bushel below is one of my favorite Hable Construction creations. These containers can be used to store anything and come in many different patterns.

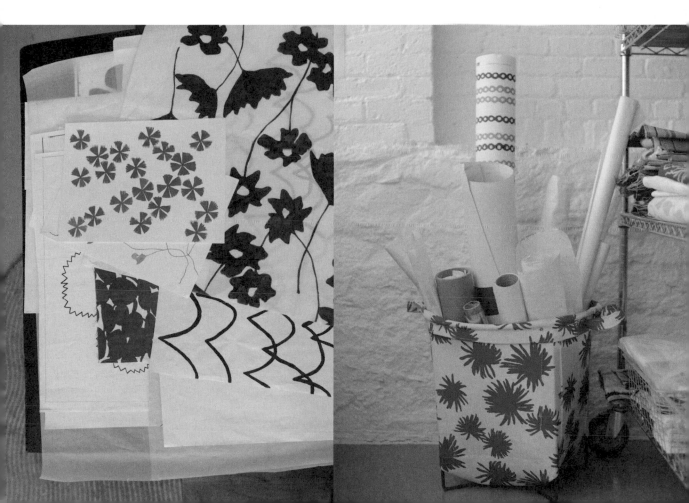

Lotta: What is your favorite kind of music to listen to while you work?

Susan: I listen to all different kinds of music, from hip-hop to ethnic. I like this Sudanese instrumental group, Sabilulungan-Suara Parahiangan. I picked up that CD on my honeymoon in Bali years ago, and it is still my favorite.
Katharine: We like to listen to NPR in the morning.

Lotta: What is your best organizing tip for a studio space?

Susan: Oh, I am a major organizer and cleaner. It's imperative to my creative process, or maybe I'm just procrastinating! I have bookshelves for all of my books and magazines. I hang ideas for certain projects on large boards so that the color palette, concept, and materials for the project stay together. We often have many things going on at once, so our studio space tends to get broken into areas for the current projects. Having clear surfaces is important for getting started, and then we "build" each project on a tabletop here, a workstation there, until every surface is covered! When we are done, we pack up the project and file it away, clean the space, and get ready for the next.

Lotta: What does the word *inspiration* mean to you?

Susan: Inspiration is when my heart races when I see something special, or a color palette that is completely fresh to me. Lately, blogs seem to do this for me. Especially in the winter, the computer is like a garden or library. Inspiration is seeing something for the first time. It's like a first date. I love it!

Lotta: What are the three best things about working in Brooklyn?

Susan: The energy, the raw talent, and the grit of the Gowanus canal right next door!
Katharine: Exactly! Brooklyn is is a vortex of artists, engineers, designers, musicians, and architects. What more could you want?

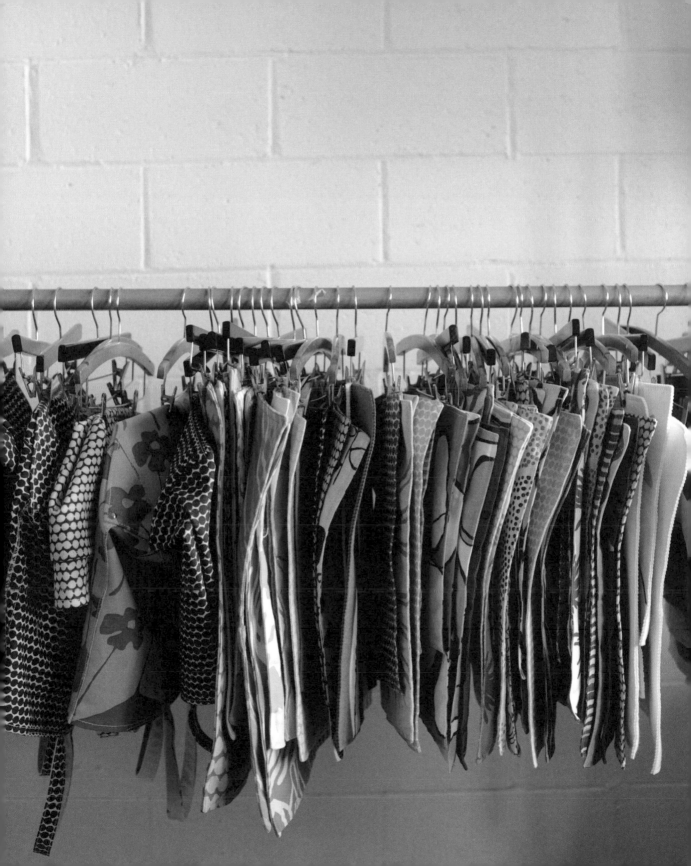

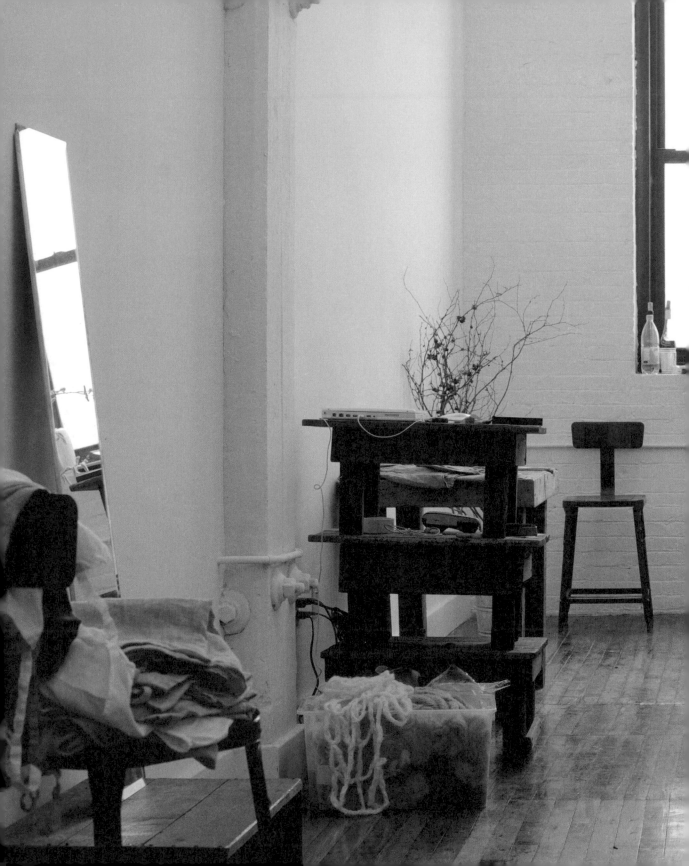

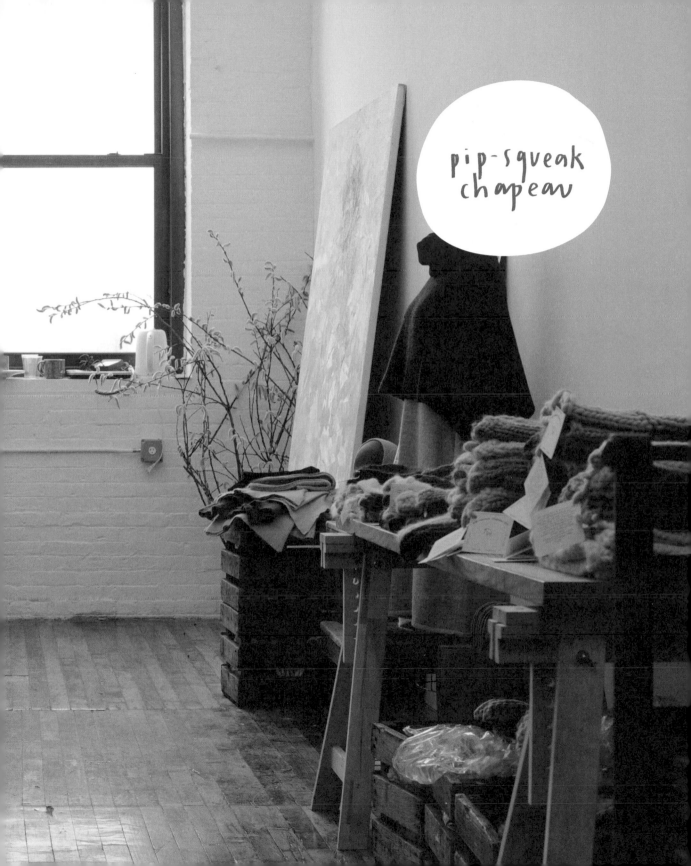

pip-squeak
chapeau

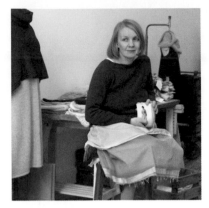

Sveta Drescher

Textile designer and owner of Pip-Squeak Chapeau

Studio size: 500 square feet (46 square meters)

Time in studio: Three months

Sveta Drescher of Pip-Squeak Chapeau creates wonderful clothing and knitted goods out of natural linen, hemp, alpaca, and wool. Her designs are simple and rustic, yet elegant and classic—as if they come from another time and place, perhaps Russia in the 1800s. Nevertheless, they are still suitable for everyday life in contemporary New York. I own a lot of her dresses and knitted hats—I can't get enough of them.

I first discovered one of Sveta's designs in a very cute baby shop here in Brooklyn. Five months pregnant at the time, I was casually browsing when I spotted an adorable little girl's apron dress made out of cotton. I immediately fell in love with this dress and knew that I simply had to have it, even though I did not know if I was going to have a boy or girl! Months later, I gave birth to a baby boy. But I still treasure this dress, which lies in my dresser, nicely folded and never used.

A few months later, I saw Sveta at a gift show. I knew I had to introduce myself and tell her my dress story. I did, and we have been friends ever since. To me, Sveta's work feels warm and familiar, as if each piece is filled with a rich heritage and stories from the past.

When I visited her studio, I immediately realized that her creative space has a feeling that is similar to that of her designs. She decorates with well-made, sturdy, simple wooden pieces—furniture from another time. The colors in her space are muted, calm, and comforting—just like her work. Time-worn fabric scraps, wood, and tea-colored linens lie around for inspiration.

Sveta recently moved to her current studio in order to be closer to home. She has two small children, so a shorter work commute made sense for her. This new studio is an elongated space with impressive high ceilings, bright white walls, and a beautiful wood floor. This is where Sveta stocks some inventory, designs her pieces, and takes care of business. This is also where she invites buyers to view her collections.

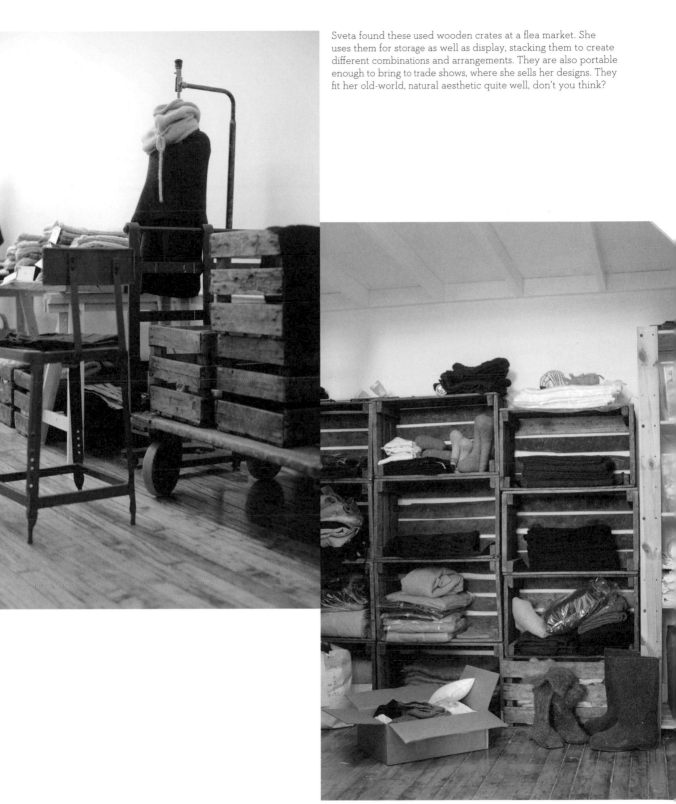

Sveta found these used wooden crates at a flea market. She uses them for storage as well as display, stacking them to create different combinations and arrangements. They are also portable enough to bring to trade shows, where she sells her designs. They fit her old-world, natural aesthetic quite well, don't you think?

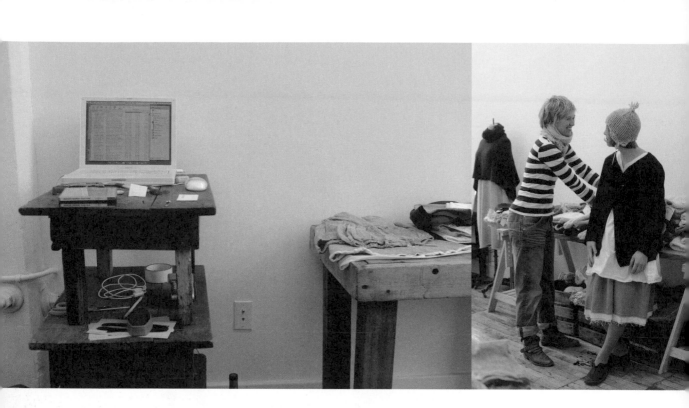

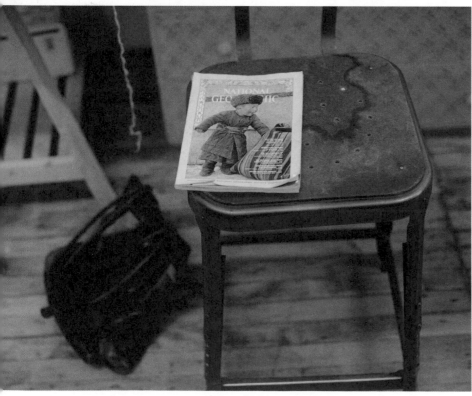

Simply constructed used pieces make for ideal workstations and display surfaces. These wooden sawhorses (above) are thrifty ways to create portable tabletops and work surfaces. Here, Sveta is doing a fitting on me—I often end up with some of her designs after a visit with her!

Sveta has treasured this issue of *National Geographic* (left) for many years now. It comes with her to every studio she occupies.

Check out the hanging envelopes (opposite page, top left). I often see these hanging envelopes used to store clothing patterns in fashion design studios. But why not steal that idea for keeping other items? You can use them to store receipts or smaller supplies like buttons, spools, and tags. Clear plastic envelopes would also work well.

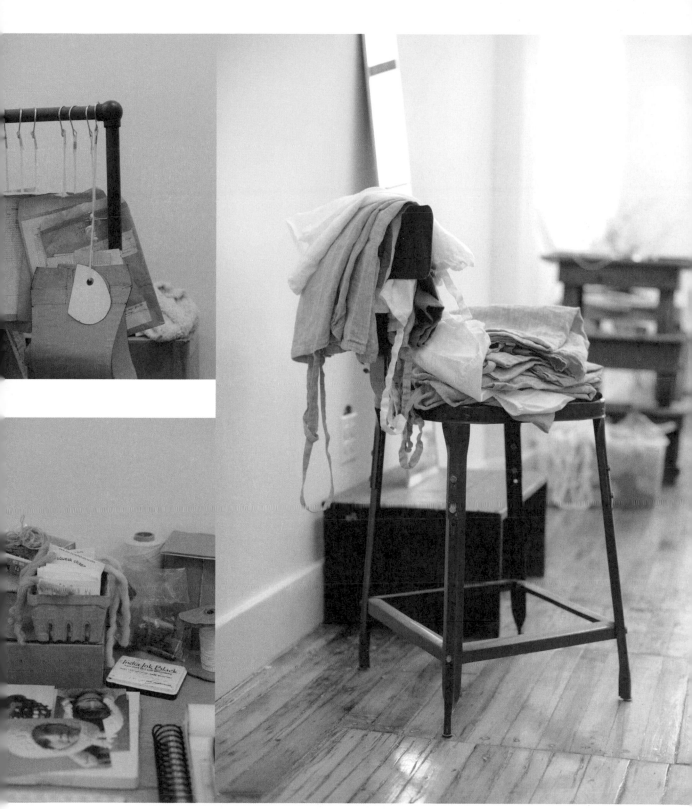

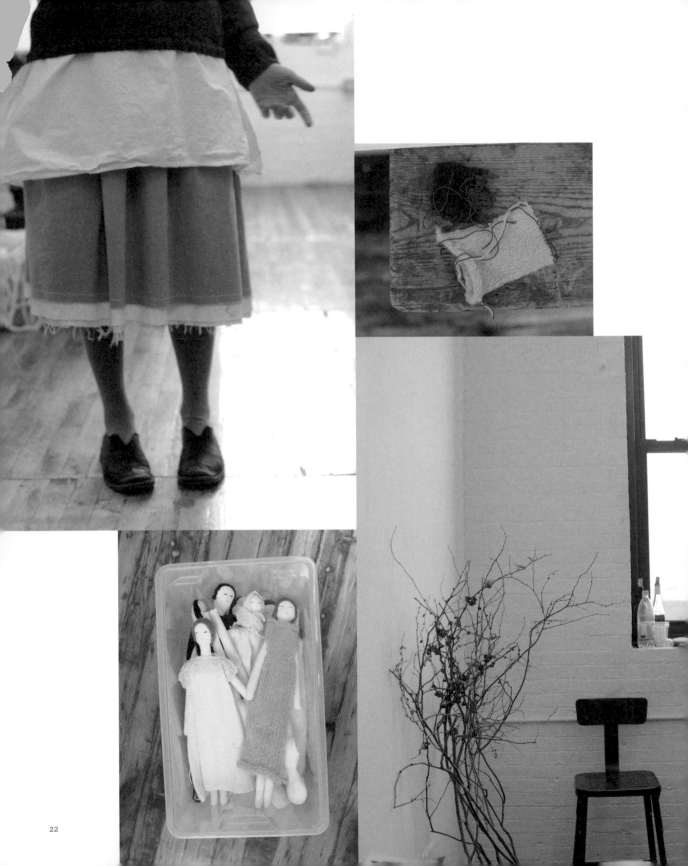

Lotta: Where do you find your wonderful used wooden boxes and pieces?

Sveta: I found some at an old sewing factory and others on the street or at flea markets.

Lotta: What do you love the most about having a studio away from your home?

Sveta: That I can do my work here and not at home!

Lotta: What do you enjoy the most about your work process?

Sveta: I just work; I actually don't think about the process much. I am mostly concerned with the result. I need to be in a certain mood to work, and I need to have certain lighting and order of things around me before I can get started.

Lotta: Can you tell me three things that you love about Brooklyn?

Sveta: I love that there is a very high concentration of creative and productive people; that I can see the sky without being out in the country (so hard to see the sky in Manhattan!); and that inspiration is so easy to find here.

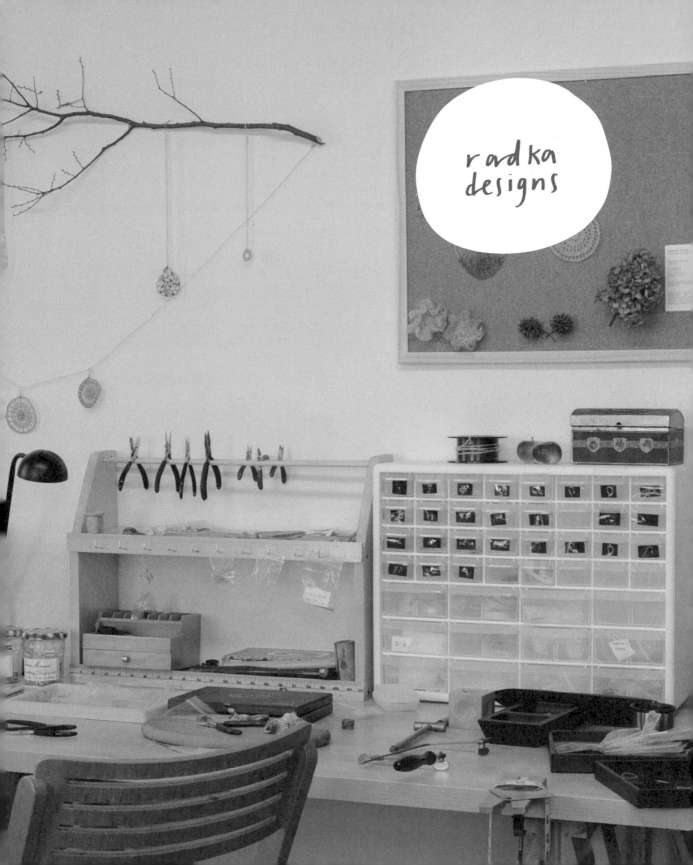

radka
designs

Radka Osickova
Jewelry designer and owner of Radka Designs
Studio size: 500 square feet
(46 square meters)
Time in studio: Since fall of 2008

I was introduced to Radka a couple of years ago in Brooklyn by a mutual friend. I was instantly impressed by both Radka's jewelry and personality. She seemed so kind, positive, and patient. When we met, she told me that she was looking for a studio space, and we chatted about possibilities. When I later heard that she had found one, I was eager to check it out and learn more about her work and process.

Radka shares her creative space with two other designers, in a studio on the sixth floor of an old building in Dumbo. Radka, who came to New York from Czechoslovakia twelve years ago, was a pattern maker for a Manhattan company for many years. While there, she started creating her hand-crocheted jewelry. (As I said above, she is a very patient person!) When we met with her, she had recently decided to leave her pattern-making job to focus on her jewelry design business full-time. Radka chose this space for its reasonable rent, its natural light (she has a spectacular view of the Brooklyn Bridge), and the company of studio mates, who share rent and also offer feedback and support.

I have to admit that I've always envied jewelry designers for their compact and intimate work spaces—no need for large shelving units or bulky equipment. The only things Radka needs in order to create her work are a desk, a chair, and small boxes full of supplies and tools. How nice!

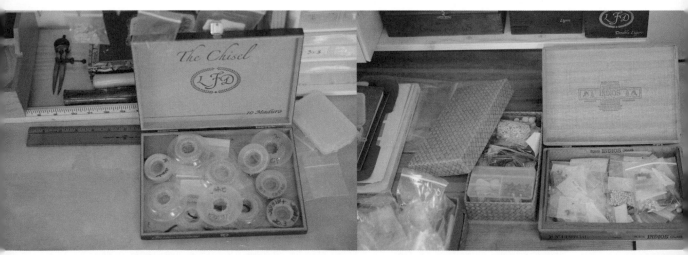

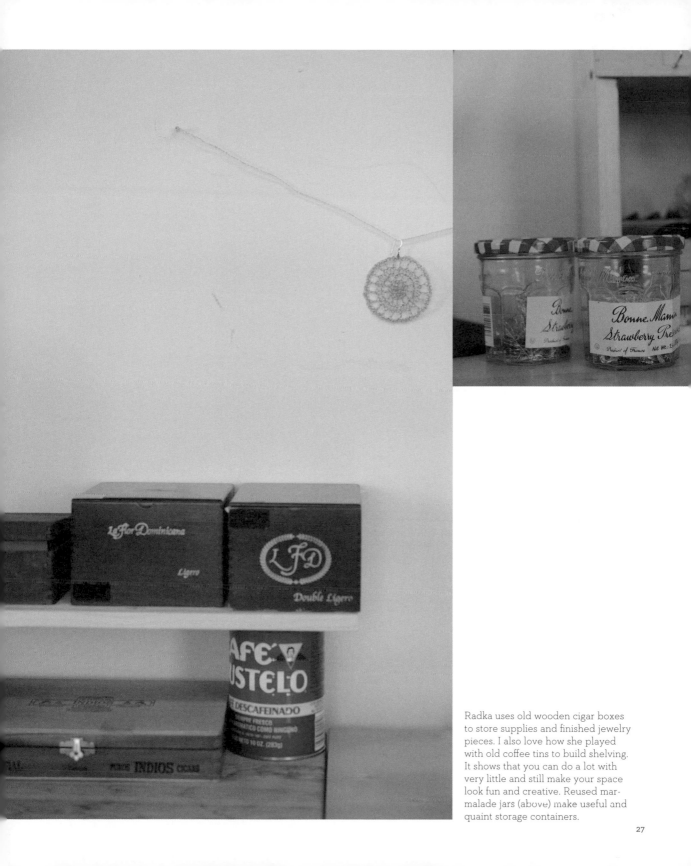

Radka uses old wooden cigar boxes to store supplies and finished jewelry pieces. I also love how she played with old coffee tins to build shelving. It shows that you can do a lot with very little and still make your space look fun and creative. Reused marmalade jars (above) make useful and quaint storage containers.

Sketches of a new logo for Radka Designs adorn these notebook pages. The custom-built wooden shelving unit (below) is perfect for any jewelry designer: it holds all of the small tools and has hooks to hang tiny parts.

How great is this branch jewelry holder (opposite page, right)? And it is so easy to make! Simply fetch a fallen branch from a local park and let nature do the work. It is perfect for displaying and serves as a design element on its own. Lovely.

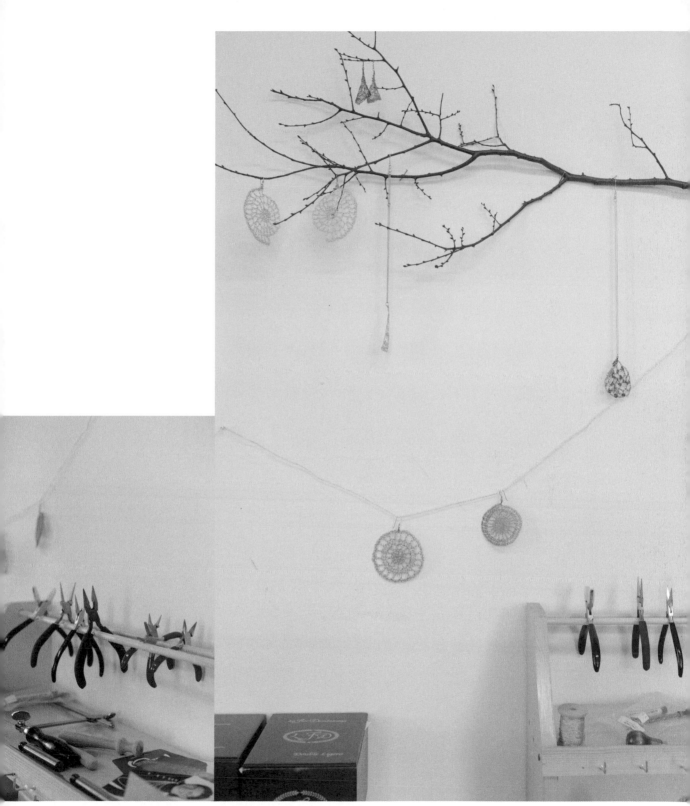

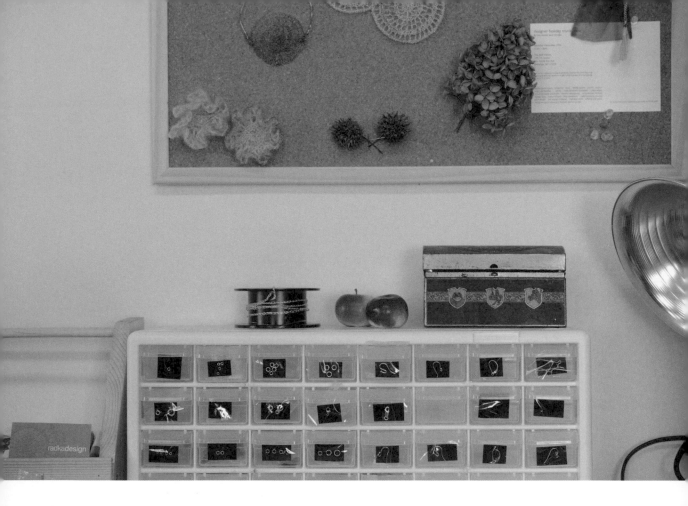

Lotta: How big is your studio space?

Radka: I share a 500-square-foot studio with two studio mates.

Lotta: What is your favorite time of day in the studio?

Radka: Mostly during the day or in the early evening. This is when I'm most productive.

Lotta: Where did you learn to do what you do?

Radka: I learned on my own, experimenting with wire. I knew how to crochet with yarn and applied that knowledge to working with wire.

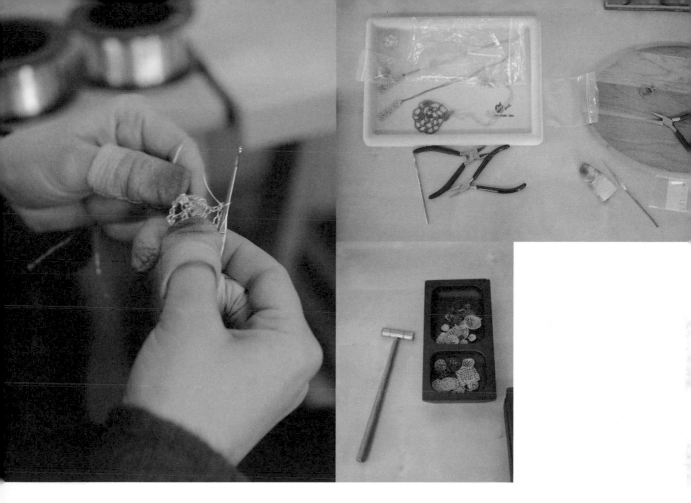

Lotta: What do you love about your work?

Radka: I love how the wire pieces feel, that they can be manipulated and shaped. I also love the freedom to make what makes me happy.

Lotta: How do you find inspiration?

Radka: I go to Prospect Park and collect leaves, branches, and seeds. My favorites are dried parts of trees, flowers, and bushes, especially when they turn orange and brown. I also like to look through books on art, fashion, and furniture. Lately I have been discovering a lot of inspiring blogs.

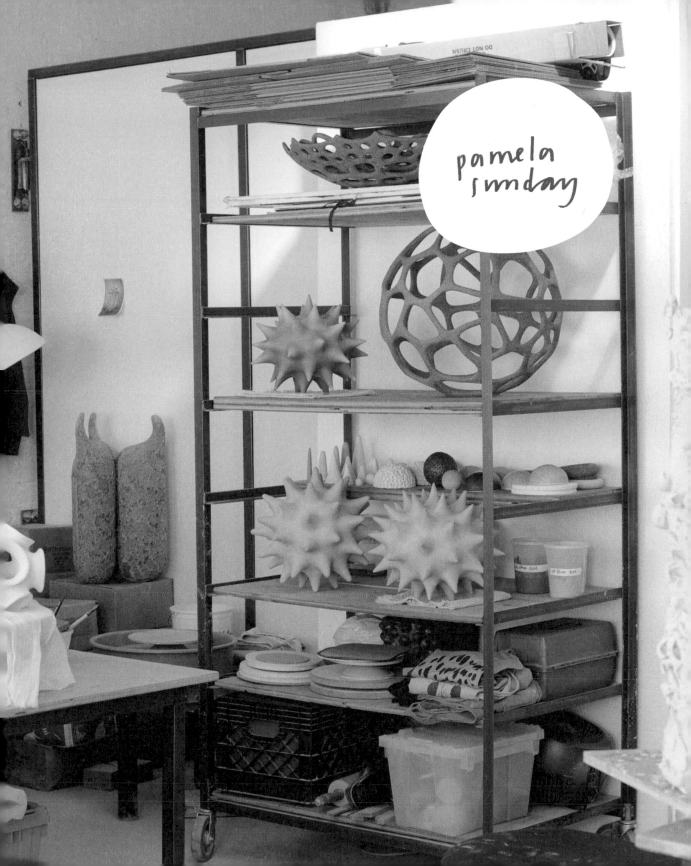

pamela
sunday

Pamela Sunday

Ceramic artist

Studio size: 200 square feet of private space (19 square meters)

Time in studio: Seven years

I first met Pamela when she came into my Brooklyn shop to buy some of my aprons, which she would later wear for work in her studio. I enjoyed chatting with her and became curious about her ceramic work, so I visited her Web site. My first impression was "Wow." I was smitten right away—she creates the most beautiful and organic sculptures. I was delighted when I finally got to visit her work space and discovered that her sculptures were even more impressive in person.

Pamela shares her studio space with other ceramic artists in a modern, industrial building nestled among trees in Carroll Gardens, a residential area of Brooklyn. A communal space is ideal for working with

All of the shelving and tabletops in Pamela's studio are custom built for her particular space. The simple and sturdy industrial shelving can be wheeled around, which is very helpful for a busy designer.

ceramics; the dust, chemicals, and large, hot kilns are usually something you don't want to deal with at home. Pamela likes her shared space, with its open floor plan, for several reasons: for one thing, she's not isolated, and for another, she can share the expensive equipment and resources with her studio mates.

One thing I noticed was how extraordinarily tidy and well organized Pamela is. (I would aspire to this kind of organization, but I'm a hopeless case.) She's also very dedicated to her work, biking to her studio six days a week and working eight to ten hours a day. Again: wow.

Pamela uses a tool cart to house a variety of gadgets.

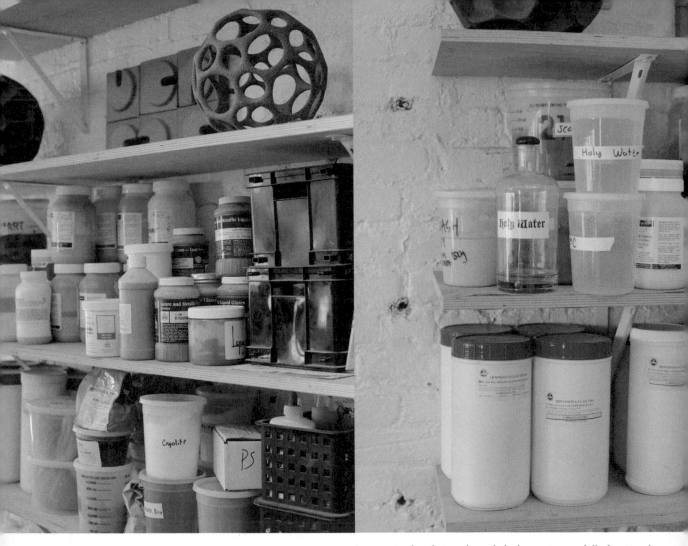

Inexpensive brackets and wood planks create a no-frills, functional storage wall.

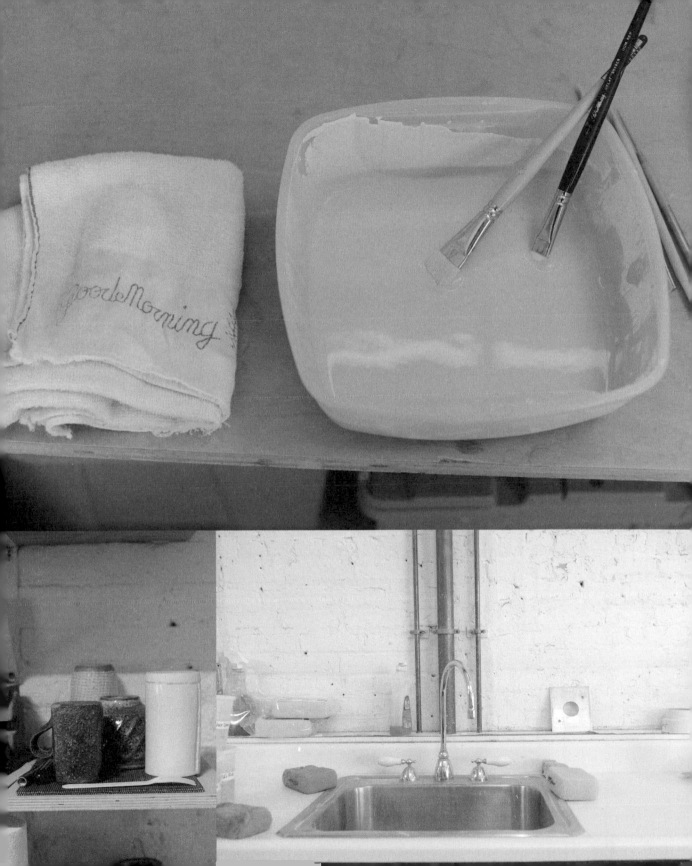

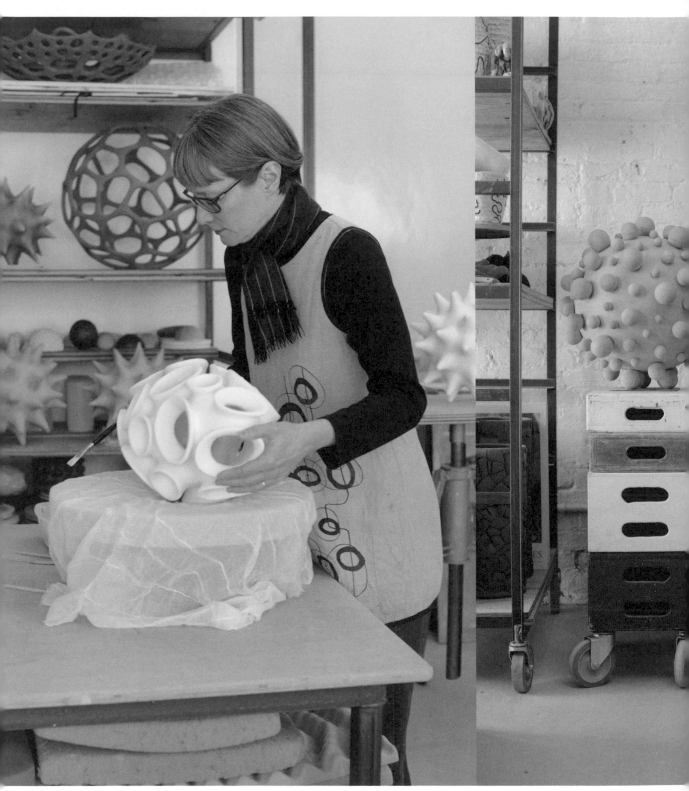

Lotta: How many people work in your studio?

Pamela: There are fourteen artists total, all working in clay.

Lotta: How did you get started with ceramics?

Pamela: About fifteen years ago, I started taking a class at a local community center with a few friends and former coworkers. One by one they dropped out, but I became more obsessed.

Lotta: Do you listen to any music while you work?

Pamela: Yes! I listen to Philip Glass, Sigur R—s, and Godspeed You! Black Emperor (also known as GY!BE). Music is a big part of my creative process.

Lotta: Clearly, your studio is very well organized. Any tips on how I can become as organized as you?

Pamela: I would recommend straightening your work space at the end of the day and putting tools back in their proper places before you go home at night. That way, you get off to a tidier start the next day.

Lotta: What motivates you?

Pamela: This is a career that happened almost by accident later in my life, so I feel an urgency to work as much as possible. I don't have time for creative blocks or moodiness!

Pamela's husband made the rolling cart (near left). He simply stacked apple crates of different heights and placed them over casters for Pamela to use as a rolling worktable. It's incredibly handy, and with a coat of paint, it's bold and different. I'd love to have one for myself!

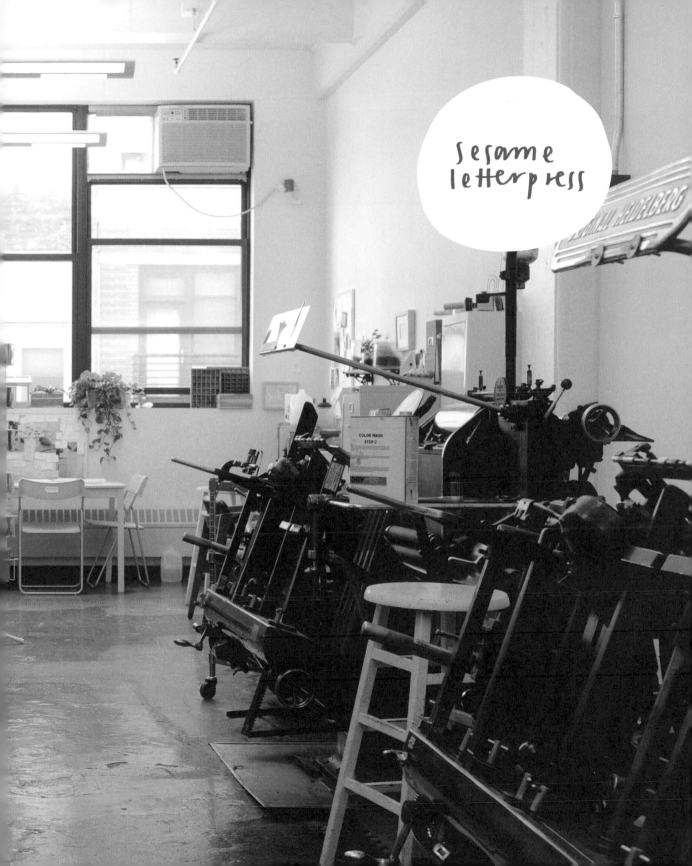

sesame
letterpress

Breck Hostetter

Owner of Sesame Letterpress

Studio size: 1,000 square feet of private space (93 square meters)

Time in studio: Two years

Breck runs a boutique letterpress studio, Sesame Letterpress, where she creates custom stationery, cards, and paper products.

Breck and I met in Brooklyn's Carroll Park one day a couple of years ago. We were both trying to keep up with our toddlers, who were running in every direction. We started chatting and quickly learned that we are both designers. I realized that several years ago I had actually bought one of her cards, a cute green thank-you card with a frog motif. As we got to know each other, we got together often, and our kids became best friends (their mommies get along very well, too). And now we live next door to each other as well! Since we do talk shop a lot when we meet, I found it fascinating to visit Breck's studio for the first time. I was so excited to see where she creates all of her wonderful and cheerful designs.

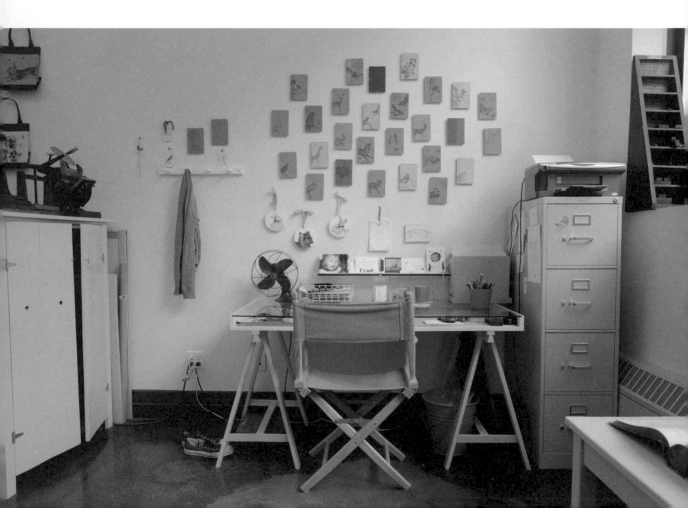

Her studio office is housed in a nondescript, commercial building in Dumbo. The place has very little personality on the exterior, but once you step inside the Sesame Letterpress headquarters, you can see that there is nothing dull about it. The walls are adorned with colorful and cheery stationery, and the space is filled with ten letterpress printers in various sizes.

Breck currently shares this space with another printer. This studio is where she meets with retail buyers and customers, stocks papers and inks, and, with her assistant, hand prints all of the work. A lot happens here, so it has to be multifunctional. She also has a smaller unit in the same building, where she stores her old work samples, more material, and, yes, even more printing presses.

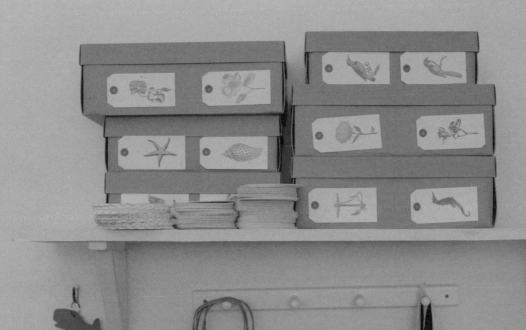

An old wooden storage unit, above, divides the desk space from the presses and production area. On top, apothecary-style glass jars display Breck's products, but these jars can be used for storage as well. The IKEA desk with a raised glass top (opposite page, bottom right) keeps useful items in view while leaving the tabletop uncluttered. What an innovative and great-looking solution to the problem of limited desk space.

Here (opposite page, top) Breck and I are hanging out by the packing table collaborating on our birthday calendar, which will include designs by Breck and me and be printed with a letterpress.

This rolling cart (opposite page, middle right), purchased at an industrial kitchen supply store, travels between the presses for easy access. It holds scrap paper, ink jars, rulers, and pencils—all the things one needs to have on hand while printing.

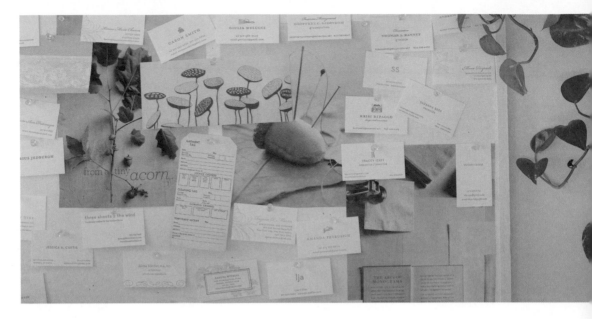

Lotta: How many presses do you have in your studio?

Breck: I have ten printing presses in the studio, the oldest dating back to 1885 and the newest from the mid-1940s.

Lotta: What do you love most about your studio?

Breck: I love the smell of the ink, the light coming through the window, the presses themselves, and having a place to come and be creative and be surrounded by things I've made.

Lotta: Why did you start printing cards?

Breck: During the holidays a few years back, I started printing cards for friends and family as gifts and really fell in love with the process. It is so satisfying to take a stack of blank paper and add color and imagery and type to create a set of really special custom cards. There is something very proper and old-fashioned about having custom stationery. I love being a part of this tradition.

Lotta: Tell me a few things that keep surprising you about Brooklyn.

Breck: The people in Brooklyn are very passionate about their neighborhoods and supporting other Brooklyn-based businesses. There is an amazing support system for artists and designers here. Brooklyn also has great restaurants and cafés and shops tucked into the corners of each neighborhood, and it is a joy to discover them.

SESAME
LETTERPRESS

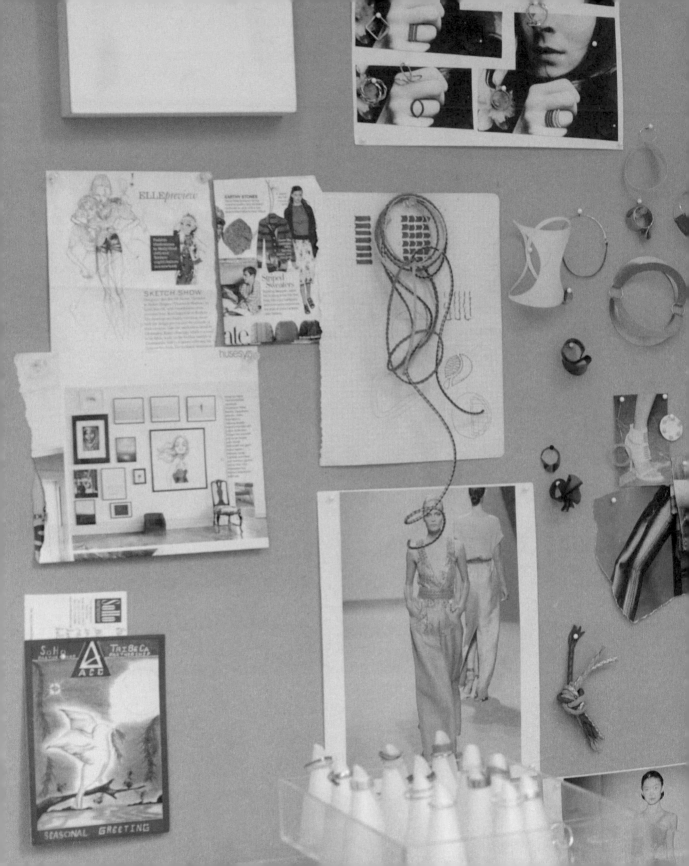

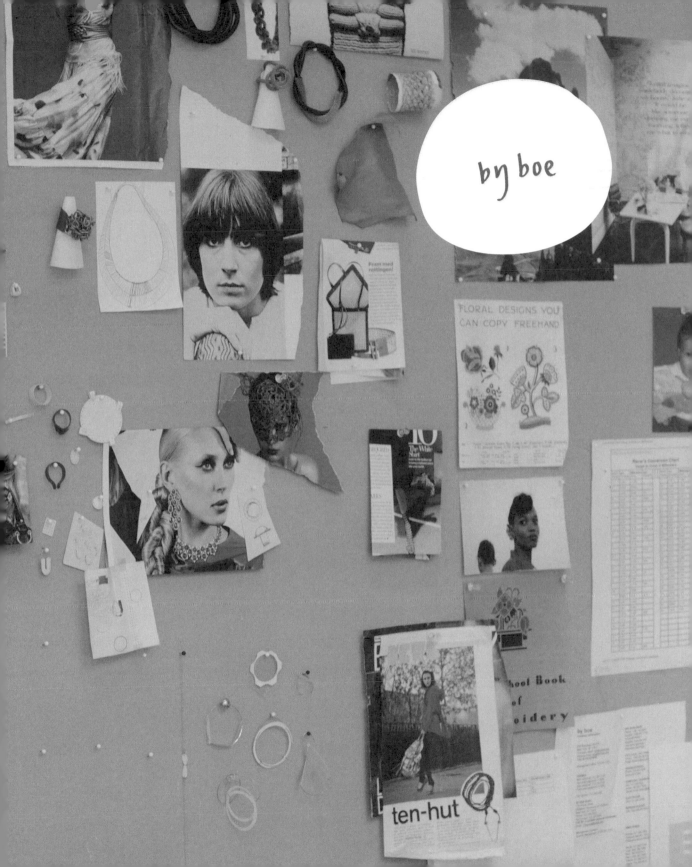

by boe

FLORAL DESIGNS YOU
CAN COPY FREEHAND

ten-hut

Annika Salame

Jewelry designer and owner of By Boe

Studio size: 80 square feet of private space (7 square meters); entire space 800 square feet (74 square meters)

Time in studio: Five years

I met Annika at the New York International Gift Fair a few years ago. She also happens to be a fellow Scandinavian and has become one of my closest friends in Brooklyn.

Annika founded her company, By Boe, in 2000. Her modern and surprisingly affordable jewelry pieces are compositions with very clean lines, no fussy details, and simple solutions. Strong colors like fuchsia, vibrant greens, and bright yellows and oranges dominate her jewelry as well as her studio, home, and even her personal wardrobe. She truly lives the way she creates!

With their bold appeal, Annika's pieces are favored by many celebrities and have graced the pages of leading magazines. Not surprisingly,

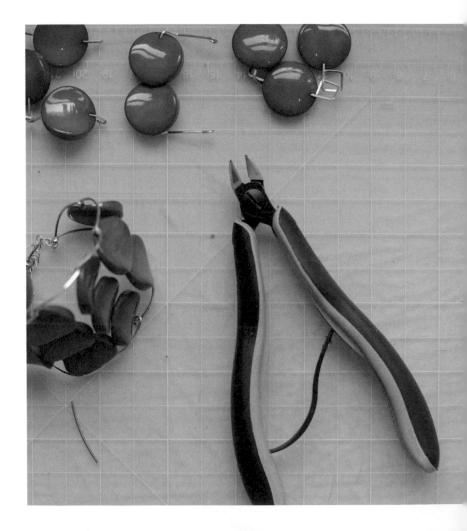

By Boe also distributes all over the world (they cannot get enough of her work in Japan!) and maintains an online boutique as well as an elegant retail shop on Prince Street in Soho.

Her office houses task desks for five employees, a showroom, a big wall of storage shelving filled with By Boe's current collection, and Annika's creative corner. Annika has decorated her office with practical, modern furniture mixed with antique pieces from secondhand shops. Her inspiration board dominates her space and changes constantly as new ideas emerge. She spends four to five days a week here in the studio and says her favorite time is midday when the sunlight floods into her office's large windows.

Wooden sake cups serve as holders for small beads.

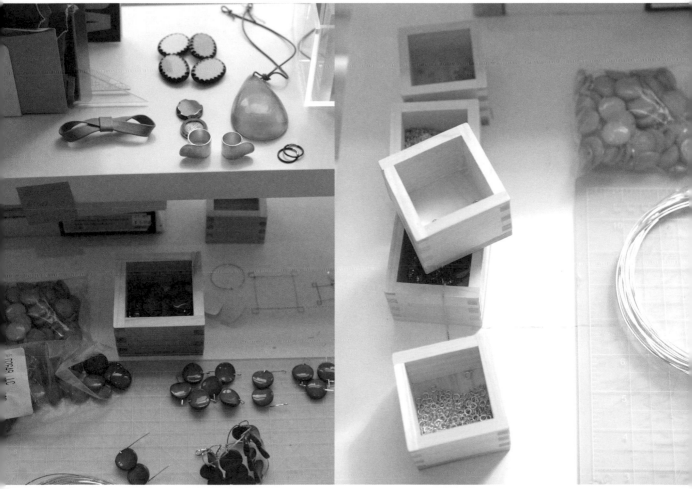

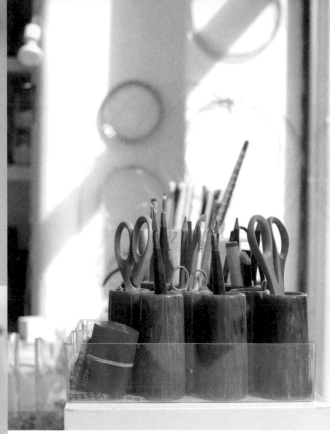

The shelving in the studio corner is filled with pieces of inspiration, supplies, pricing, and notes. Ceramic vases (above) make good containers for tools. Instead of adding walls to her space, Annika cleverly hung cloth panels in contrasting colors to separate and define the different work areas in the studio (opposite page, bottom).

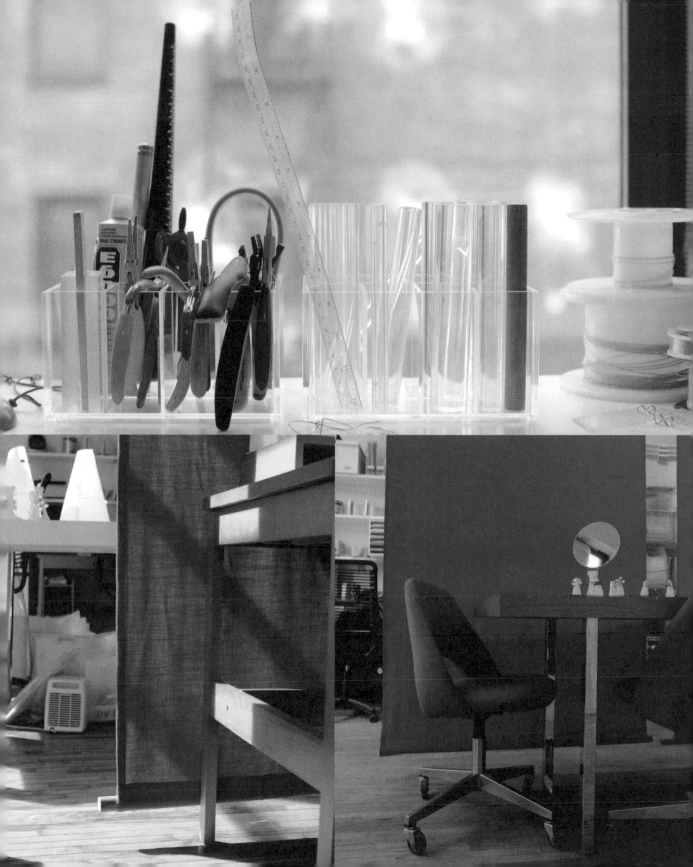

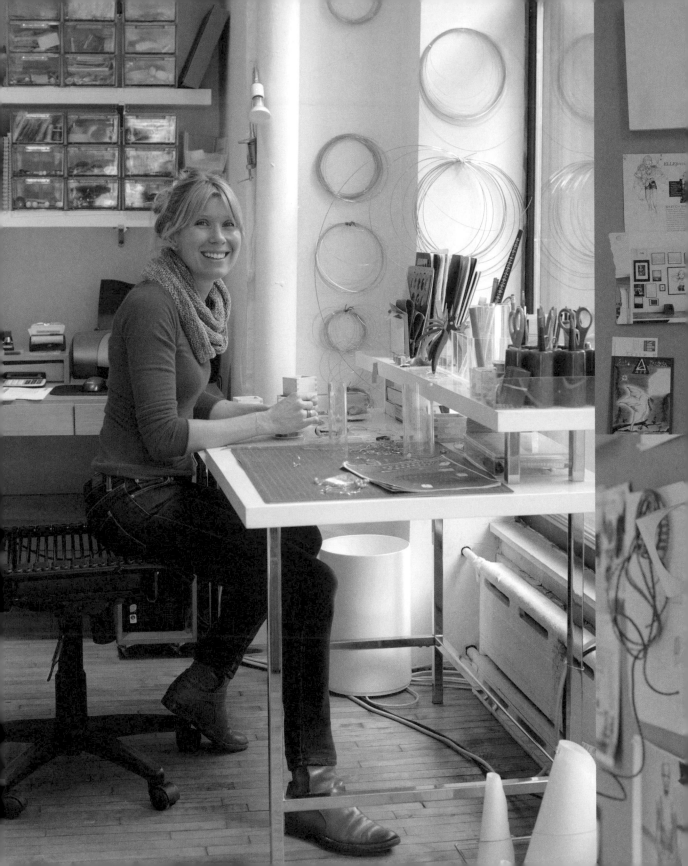

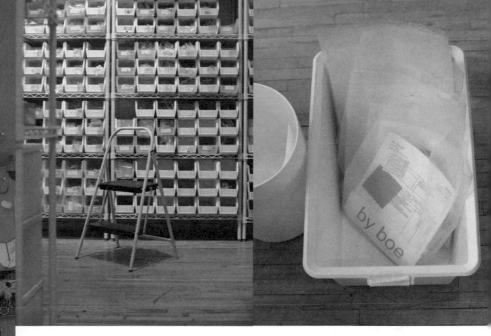

Annika stores her wide selection of inventory in plastic bins, stacked in wire shelving from top to bottom. Each order is sorted into a plastic bag and stored in a simple plastic bin (above right).

Lotta: How does Brooklyn inspire you?

Annika: I am constantly inspired by the collective artistic spirit of the people who live here.

Lotta: What do you love the most about being a designer?

Annika: I love the satisfaction and thrill I get from seeing and feeling a design emerge and become complete. It's a tangible reward for my work. I also like the fact that seeing exhibitions, watching movies, reading books, and other fun things for inspiration can be considered "work"!

Lotta: Tell me three things you love about your studio.

Annika: The windows, watching the bustling street life below, and my corner nook with all my tools.

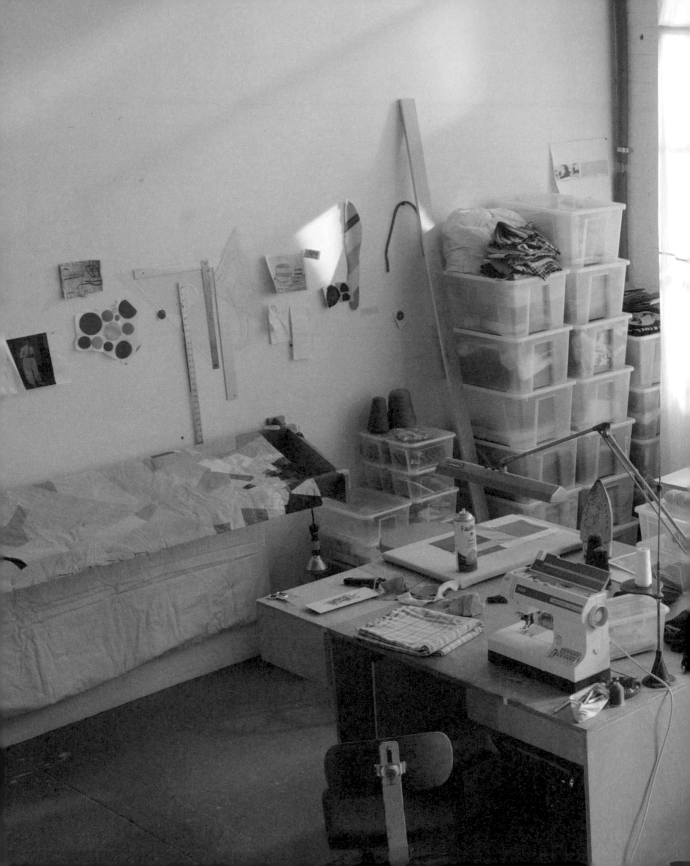

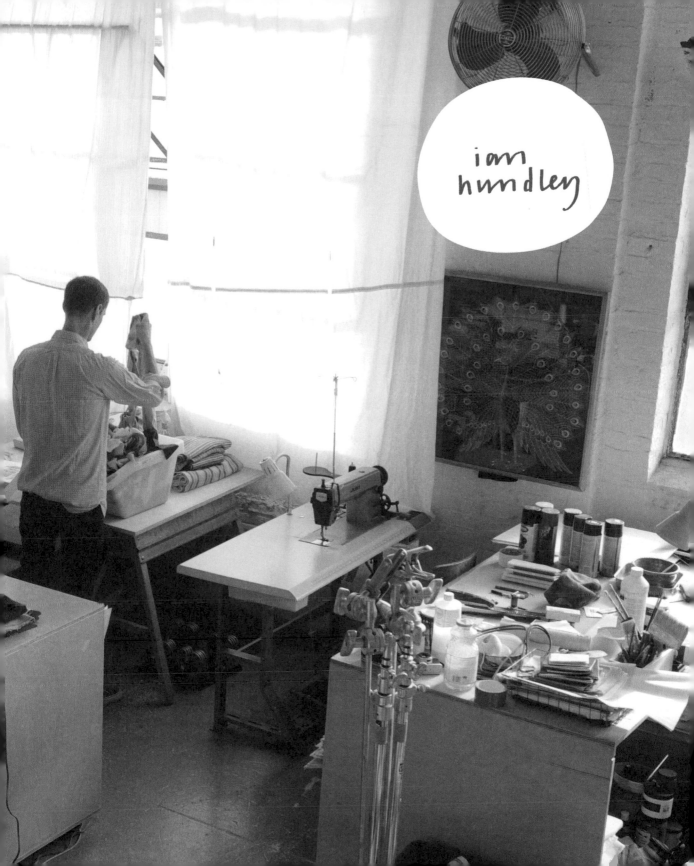

ian
hundley

Ian Hundley

Artist

Studio size: 600 square feet (56 square meters) with 300 square feet (28 square meters) of private space

Time in studio: Twelve years

When I first discovered Ian's amazing quilts, I was wholly impressed. I had recently started making my own quilts, and I was delighted to find inspiration for contemporary methods of creating quilts from swatches. I was even happier to learn that Ian lives and works right here in Brooklyn. I quickly asked him if I could visit his studio, so I could learn how and where he creates his fabulous works.

Ian shares his gorgeous studio loft space with his brother, Marc, who is also an artist. The studio, located along the Hudson in Williamsburg, is in a huge industrial building with wonderfully large warehouse windows. It's settled far away from the hustle of bars, shops, and foot traffic so there is no distraction for this focused artist.

Among many things, Ian creates quilts inspired by maps. They have been displayed in many shows locally and abroad. He also works as a dressmaker and often consults for major fashion labels during New York's Fashion Week. Ian started out creating his designs in his bedroom in 1996 and was able to move the operation to this space in 1998. Sharing the space with his brother is a good solution, since they keep different schedules, and there's plenty of alone time for each of them to create.

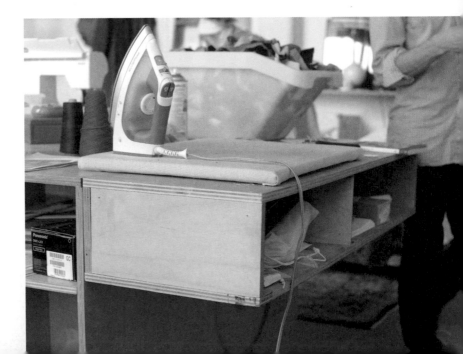

Ian custom built his desks to suit different tasks, such as this ironing table with homemade board and pad on the surface. It stands at the perfect height and has open shelves underneath to hold supplies.

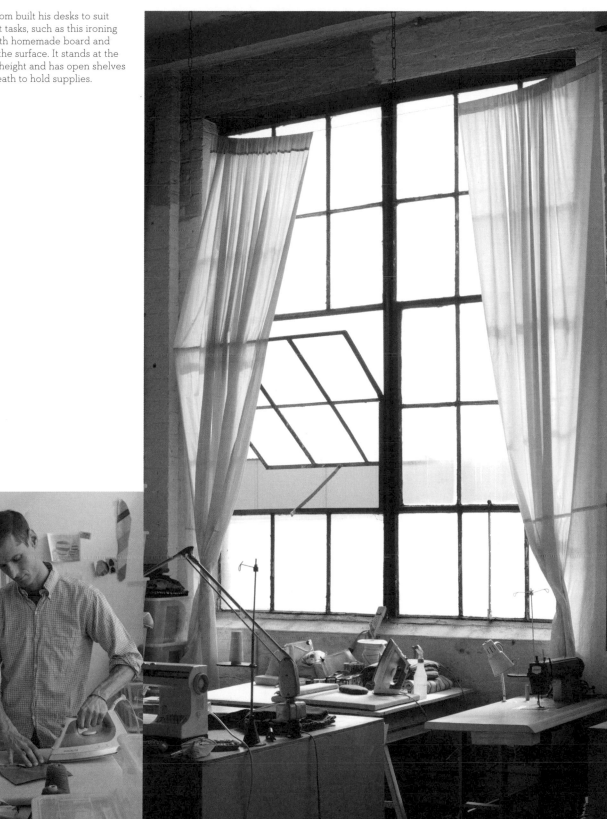

I was tickled by his homemade magnetic pin board (right), a very modern take on the pincushion. I love Ian's idea to sew simple muslin zipper bags in various sizes and use them to store additional tools, supplies, and receipts (bottom left).

When Ian embellishes and embroiders his quilts, he uses this custombuilt quilt stretcher (bottom right). I had never seen such a thing before and was excited to learn about it.

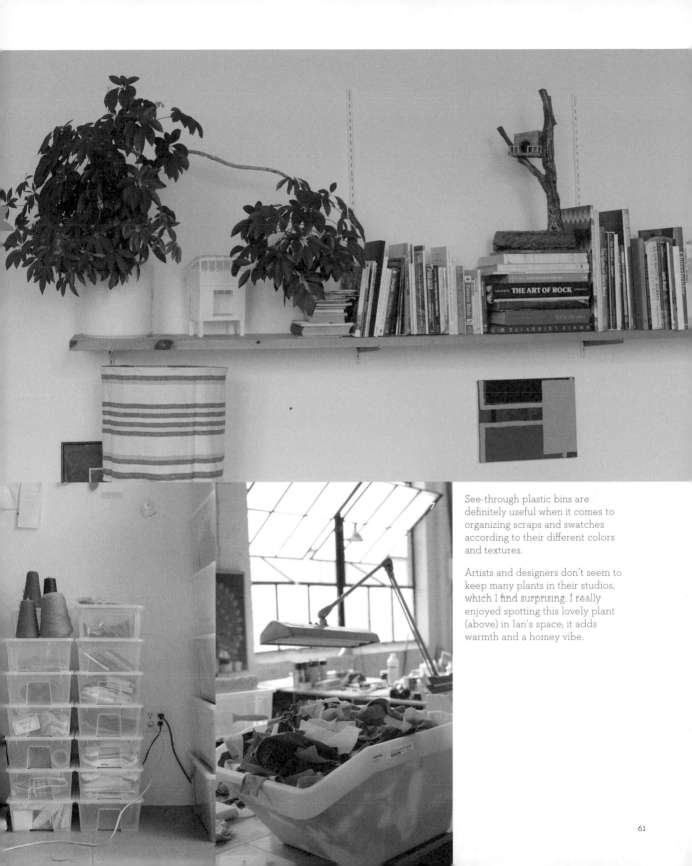

See-through plastic bins are definitely useful when it comes to organizing scraps and swatches according to their different colors and textures.

Artists and designers don't seem to keep many plants in their studios, which I find surprising. I really enjoyed spotting this lovely plant (above) in Ian's space; it adds warmth and a homey vibe.

Lotta: What do you think makes a great studio?

Ian: For me, the atmosphere needs to be good. Light is crucial, and I need some sense of privacy. For me to be able to work, it also needs to be organized. I usually have music playing, and a telephone headset is good as well, so I can chat while working; otherwise I make myself crazy.

Lotta: What do you enjoy most about your work process?

Ian: I enjoy getting a little obsessed with the steps that lead up to the end, which is always a little unknown. Pulling all-nighters in the studio and the feeling of chaos.

Lotta: What do you find inspiring about Brooklyn?

Ian: Brooklyn is my home. I moved here sixteen years ago, and it just felt right. From where I am at the base of the Williamsburg Bridge, it's a ten-minute bike ride to Manhattan. I like the perspective on the city in Brooklyn.

Lotta: What does *inspiration* mean to you?

Ian: Dealing with limitations.

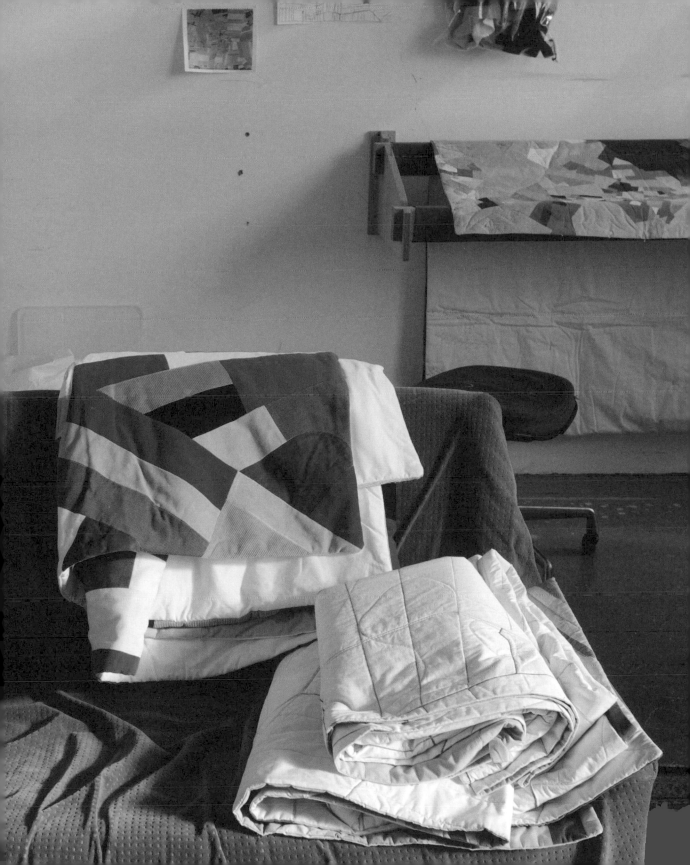

mociun

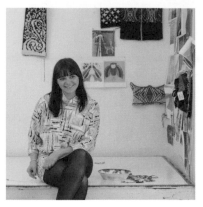

Caitlin Mociun

Clothing designer

Studio size: 400 square feet
(37 square meters)

Time in studio: Three years

I found one of my all-time favorite dresses, a Mociun signature dress, at Bird, a wonderful clothing store here in Brooklyn. The cut and design of the dress were unique yet simple, and the pattern of the fabric looked like a watercolor drawing. After buying the dress, I looked up the Mociun Web site and was even more intrigued after browsing their collection. I wanted to learn more about the woman behind these creations. I called Caitlin and asked her if I could visit. She has all kinds of creative projects going on at one time, as well as several collaborations with other artists and designers.

Caitlin dedicates a large room in her apartment to her design business. The space is dominated by a massive custom-built worktable and is filled with her creations: skirts, dresses, hand-braided necklaces, tote bags, digitally and hand-screened fabrics, and her inspiring sketches. She currently has seven fashion collections that are sold internationally. Caitlin, who shares her apartment in a residential building with five of her friends, says working from home doesn't really distract her; she's a dedicated designer and gets her work done when needed.

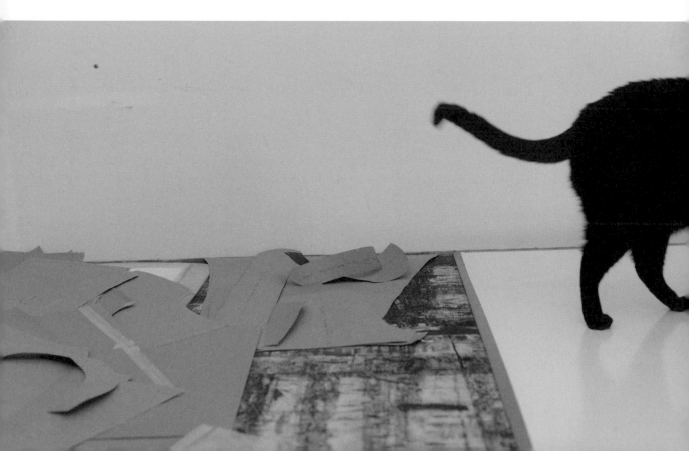

In Caitlin's work space, one big worktable serves many purposes: she uses it to screen print some of her designs, cut her patterns and bolts of fabric, and store plenty of materials underneath. Her cat, Judas, is a dedicated studio mate.

Her watercolors and sketches turn into designs digitally printed on fabric (right).

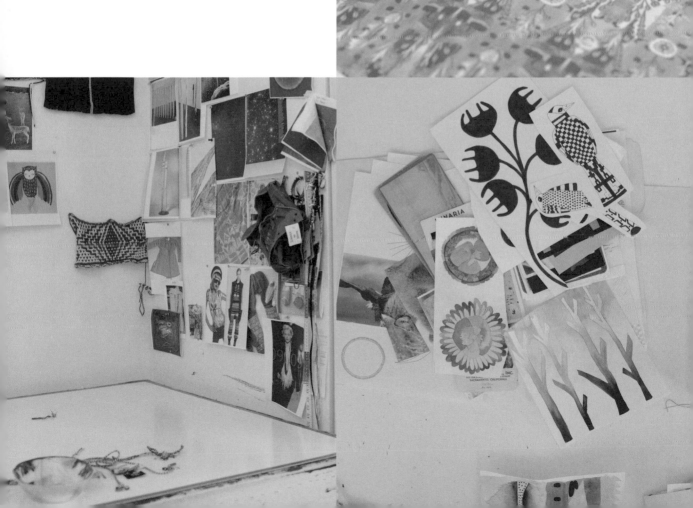

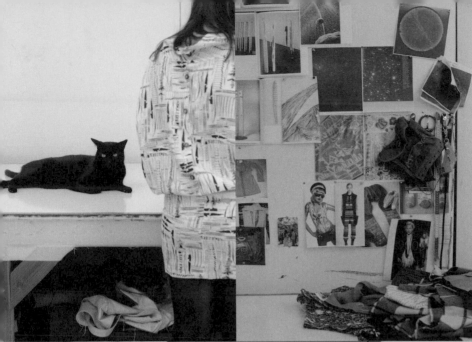

Caitlin's inspiration wall (left) is constantly changing and is an important part of her work process. This is where she pins up images that inspire her and swatches of fabric that she is currently working with or plans to use.

This small bathroom (opposite page) is where she stores her screens and cleans them after printing. IKEA shelving holds ink jars and books.

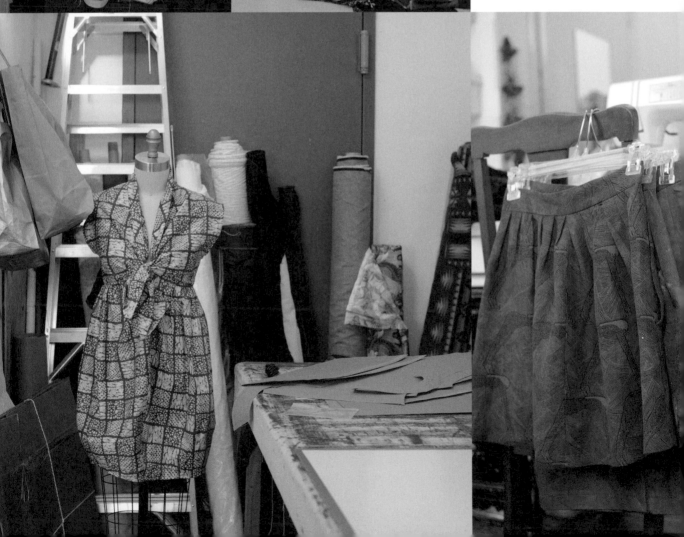

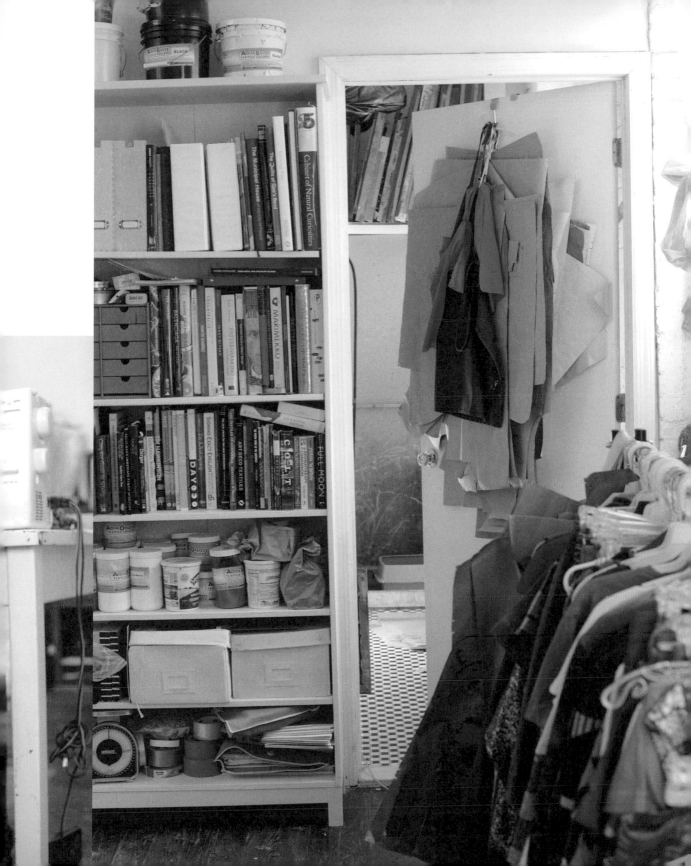

Lotta: What is your favorite thing about being a designer?

Caitlin: I really love when I do something, see something, or hear something that inspires me and I have the means to make something from the inspiration. I like to see my own process as it develops and where that one idea takes me. I am always surprised about where I end up. It's never a straight, simple path, so designing is always interesting.

Lotta: What do you think makes a great studio?

Caitlin: I think it's about how the space makes you feel. Part of that for me is how I set up that space. The way a space is arranged affects how I see things and the flow of my work. I often move [furniture in] my studio around and reorganize things if I am feeling stuck . . . I also have great light in my studio, which makes being in here a pleasure.

Lotta: What songs do you like to listen to when you create?

Caitlin: Music questions are always hard for me to answer. I listen to such a wide range of music and find that I like really different things for creating each aspect of my work. As much as I listen to music, I listen to *Radiolab* or *This American Life* when I am working. I also like nonfiction books on tape.

As for what I have been listening to lately, my friend's new album just came out, and I think it's great: the band is Yeasayer and the album is *Odd Blood*. I listen to Kate Bush all the time—pretty much any album of hers. Fever Ray, Little Dragon, Paul Simon, and Cyndi Lauper have been frequenting my speakers in the last month.

Lotta: What do we need more of here in Brooklyn?

Caitlin: Good vegetarian and vegan restaurants!

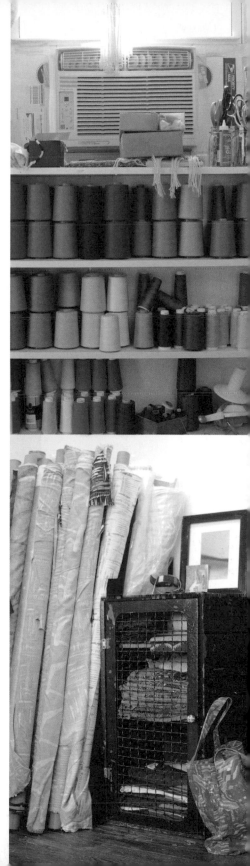

stockholm

Stockholm—the "Nordic Venice"—is my hometown.

It is a beautiful city surrounded by clean water, nature, and beautiful sights. It is also a city where trends pop up and disappear faster than you can count to three. The people here are keenly tuned into fashion, food, design, and the very latest fad.

I grew up in a suburb in the south part of Stockholm, right next to the first IKEA store (which explains a lot). Naturally, I also went to school in Stockholm, where I was first introduced to the arts and given plenty of support and inspiration while exploring art and design.

Sweden is a country that supports the arts. Government programs and grants provide support and opportunities for artists and designers, and brilliant design schools can be found all over the country. Not surprisingly, Swedish design is highly promoted by the government and marketed on the international scene with great success.

A lot of things have changed in Stockholm since I moved away fourteen years ago. The city today seems a bit more colorful. Now I can find restaurants serving food from all over the world, and there is a general openness to different types of people and cultures. It is becoming a more and more diverse city.

Working and living as a creative person in Stockholm seems like such a pleasant existence to me. You have social support—medical and financial assistance no matter what. The quality of life is great, with culture, delicious food, incredible parks, clubs, museums, and a proximity to nature—plus paid maternity leave for more than half a year, even if you freelance. Wow!

I am very excited to share some of my favorite Stockholm studios. You will meet some of my very best friends, along with some people whom I have admired from afar for a long time. They are a very inspiring bunch, and I hope you enjoy visiting them as much as I did!

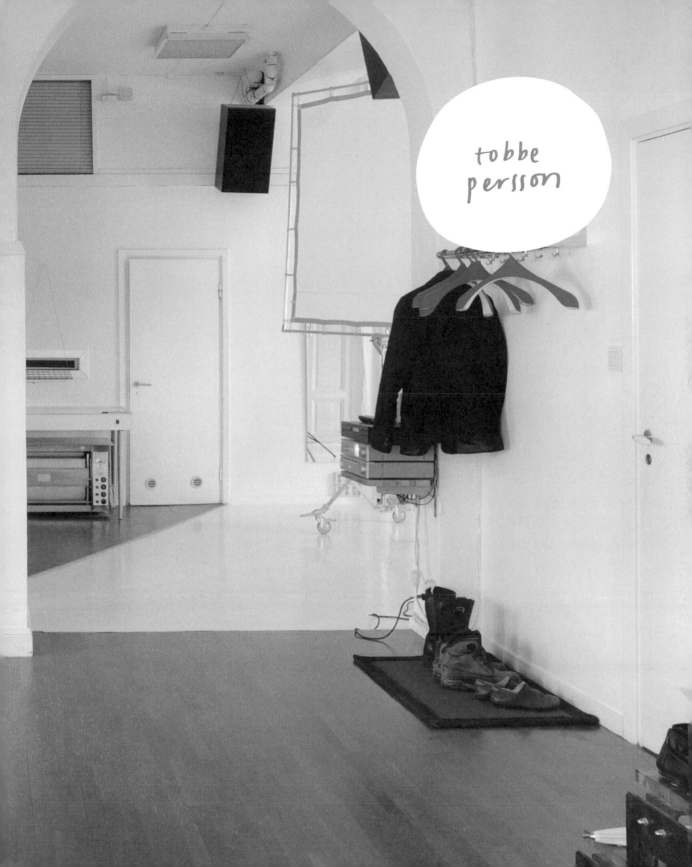

tobbe
persson

Tobbe Persson

Photographer

Studio size: 1,044 square feet
(97 square meters)

Time in studio: Thirteen years

The first visit on our studio tour in Stockholm was with our good friend Torbjorn, or "Tobbe," as most of his friends know him. I met Tobbe through Jenny, the photographer for this book. Tobbe has been a professional freelance photographer since 1993. He shoots portraits and fashion photography and does post-production work in his studio, which he shares with one other photographer. (They have fairly different schedules, but they enjoy the company and the chance to bounce ideas off each other on the rare occasions that they do overlap.)

It had been a few years since I last visited his studio, located in the northern part of Stockholm. What I really like about Tobbe's studio is how it feels like a highly organized and professional photography studio just as much as it feels like a welcoming home, where you can sit in the kitchen over coffee and cinnamon buns, which we indeed did.

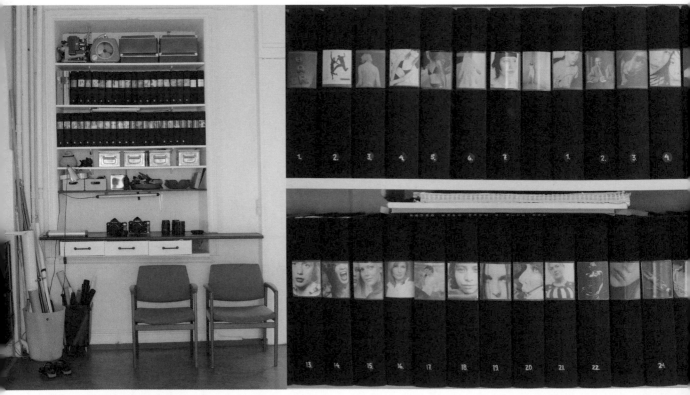

I just love how Tobbe has organized all his negatives and labeled the notebooks with photographs to remind him of the shoot: talk about having visual memory.

Behind these large, white custom-made linen curtains (right) Tobbe has plenty of storage space for equipment. The curtains help keep the rest of the space clear and free from clutter.

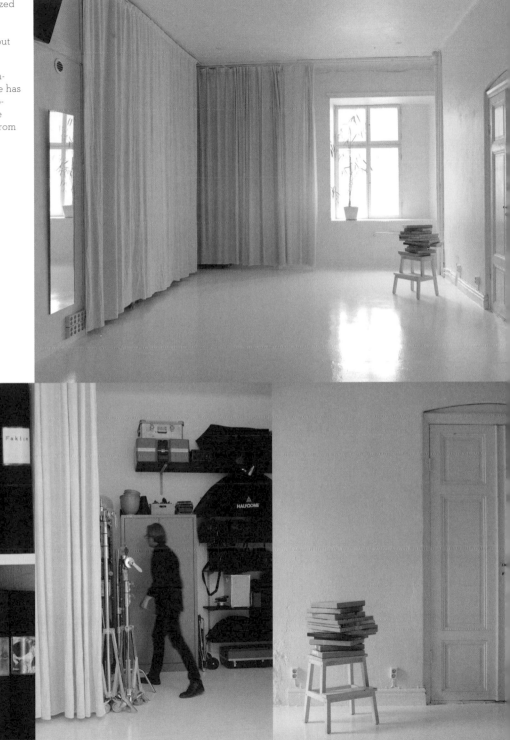

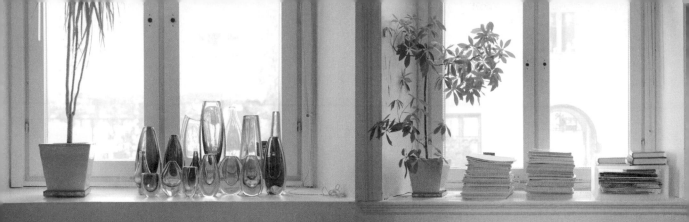

I really like these wide window ledges, perfect for magazines and a collection of antique glass vases. There is a well-lit space in the corner (below left) where models and celebrities get made up for shoots. Upstairs there is room for another photographer's work space (opposite page, top right). And look at Tobbe's CD collection (opposite page, top left)—it is arranged alphabetically—so organized!

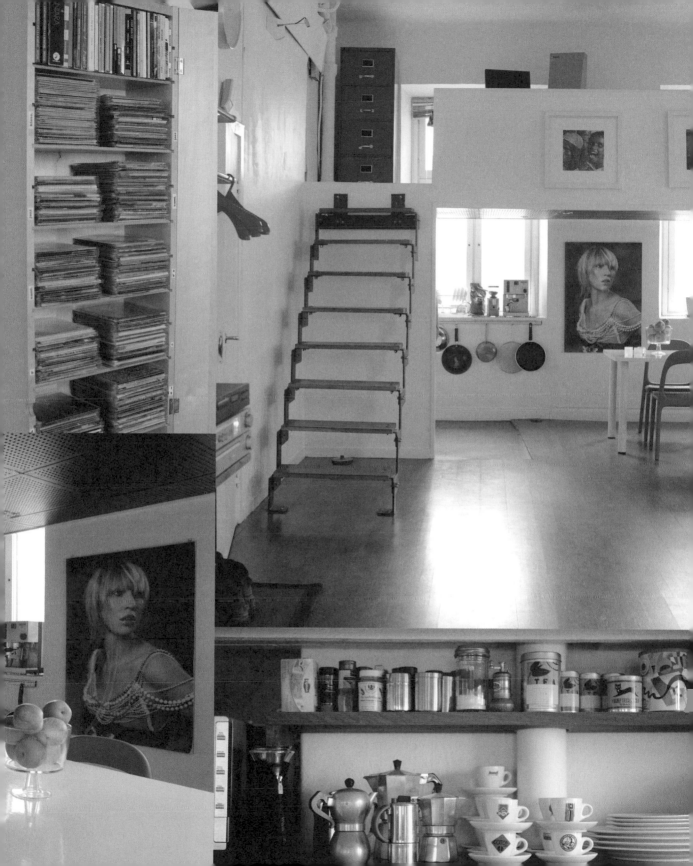

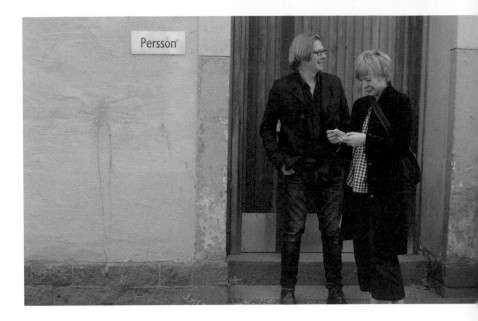

Lotta: What do you like the most about your studio?

Tobbe: The space has a very good layout, and I love the high ceilings.

Lotta: How would you describe your studio style?

Tobbe: Organized and light. It's a mixture of IKEA and secondhand pieces.

Lotta: Do you listen to music when you work?

Tobbe: All the time. It is actually very important during shoots to set a mood or a tone, so music is an important tool for this job.

Lotta: Can you tell me three things that keep surprising you about Stockholm?

Tobbe: One: My friends (and sometimes myself!). Two: The love-hate relationship that I have with the city. It's easy to forget how horrible Stockholm can be on a gray and cold day in February, with sleet, gloomy faces, and expensive cappuccinos. Then, a couple of weeks later, it's all love. The light, the streets, the water, the islands, the creativity, the happiness in people—it becomes my favorite city again. Three: How fun it still is to explore Stockholm—there are always new parts and places to be seen.

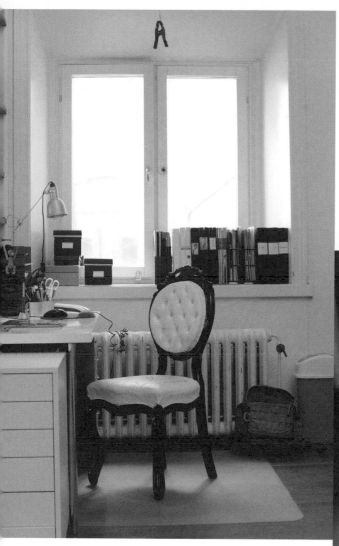

My favorite piece in Tobbe's studio is an old velvet chair that he and his girlfriend refurbished. They painted the wood frame black and the velvet white (using a lot of paint, I imagine) and then started writing on it with black marker. What a fun idea.

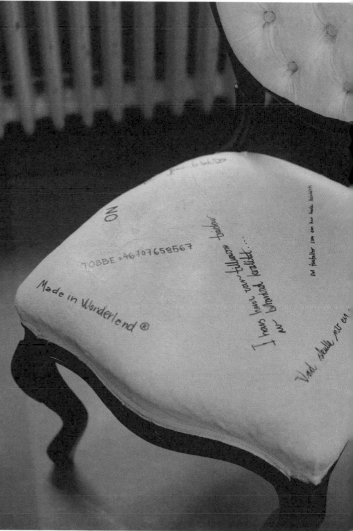

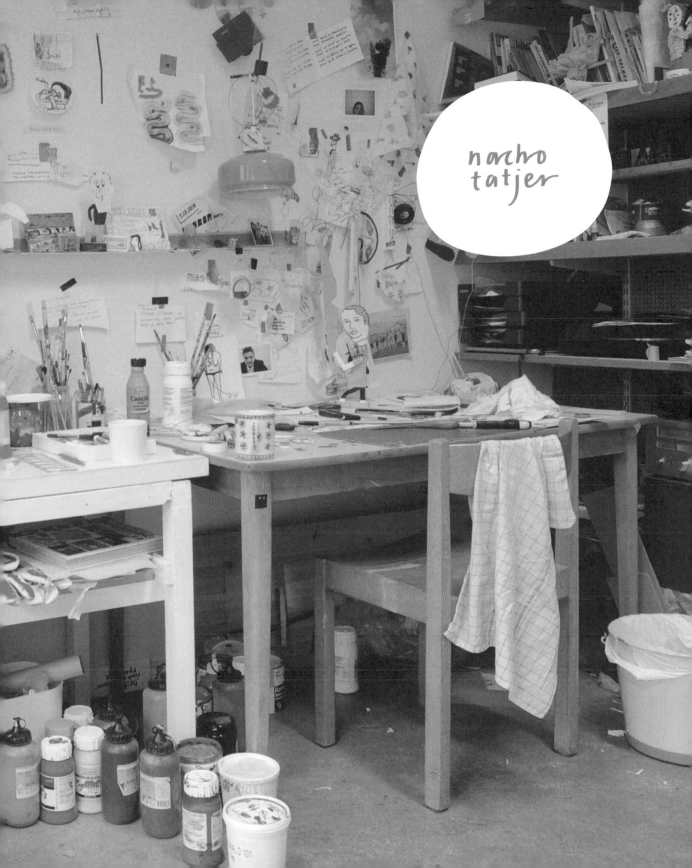

nacho
tatjer

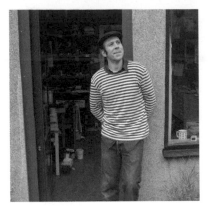

Nacho Tatjer
Artist
Studio size: 279 square feet
(26 square meters)
Time in studio: Four years

It seems like everything Nacho touches—rubber bands, empty milk cartons, tea bags, jars, paper bags, wood pieces (well, you get the picture: everything)—becomes a part of his art. These things all become players in his creative world. As an artist, Nacho illustrates for magazines and products, does film photography (which he develops in a tiny bathroom in his studio), and creates mail art that he sends to other creatives around the world. I find his clever use of the ordinary to be fun and truly liberating.

Nacho was born in Spain and now calls Stockholm his home. His studio is located in the basement of a residential apartment building, where he lives with his wife (whom he refers to as "my Jenny") and their two children. Nacho goes down to his studio every day, often working into the night. His studio, to be honest, is a mess, but it's such a great and inspiring mess! With every step I took, I made a new discovery.

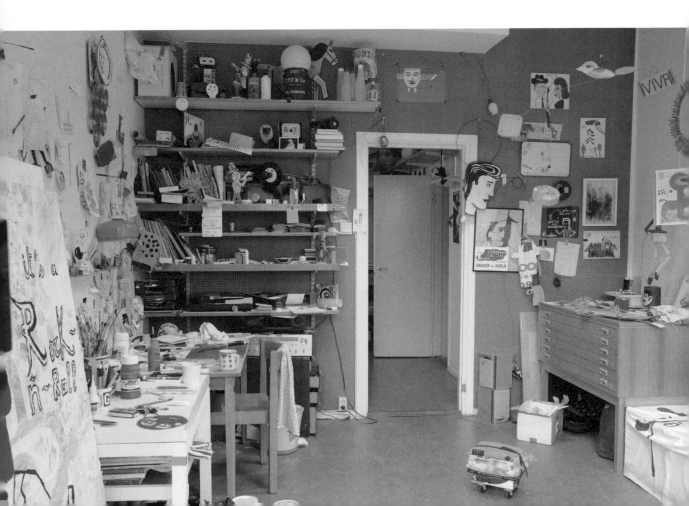

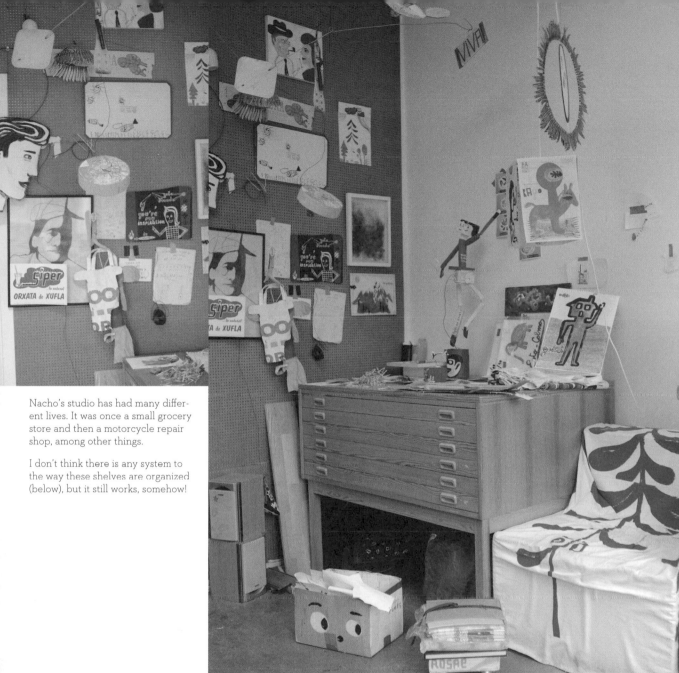

Nacho's studio has had many different lives. It was once a small grocery store and then a motorcycle repair shop, among other things.

I don't think there is any system to the way these shelves are organized (below), but it still works, somehow!

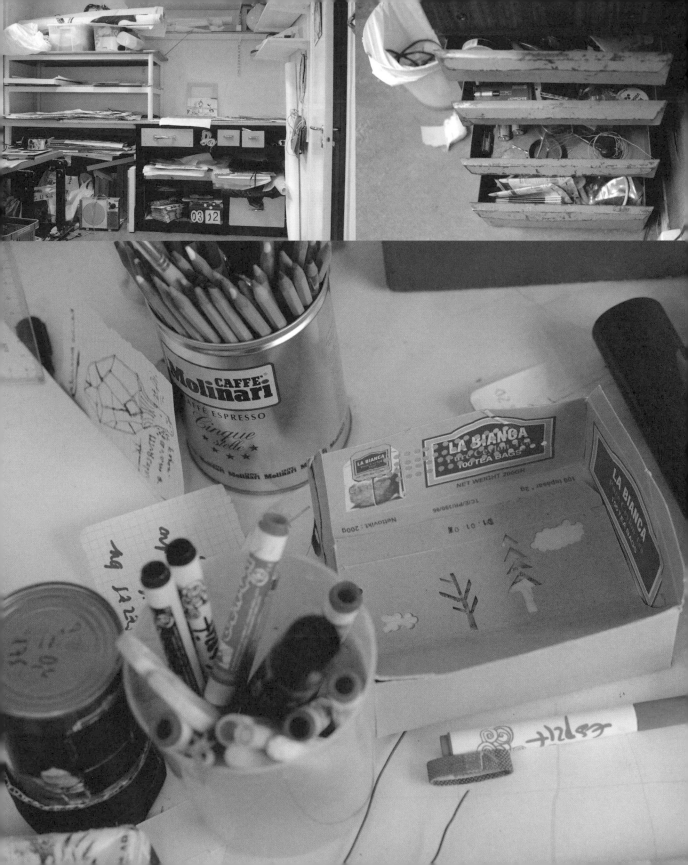

In the back room (opposite page, top left) Nacho stores papers and supplies. The darkroom takes up the little space there is in the tiny bathroom beside this room.

Nacho stores his tools of the trade in metal drawers and keeps pens in recycled cans, jars, and even empty food packages (opposite page, bottom). He was reusing materials and creating eco art for light-years before it was trendy. Here, an empty tea box becomes an art piece.

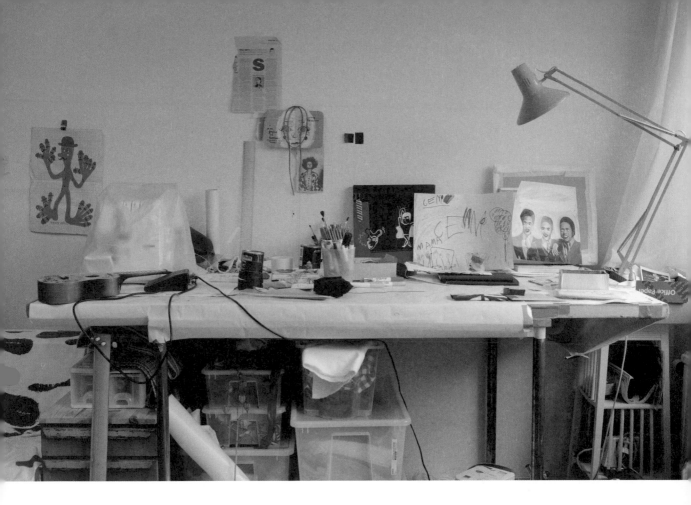

Lotta: How did you end up in this space?

Nachos: It was the very first atelier I saw once I moved into the neighborhood, and the closest to home. I liked the place months before I moved in.

Lotta: What would you like to change about your studio?

Nachos: I wish it were bigger. I like to have a few projects going at once, so I'd welcome more space. It gets messy pretty quickly, but I'm okay with that—it makes me feel comfortable.

There are several work desks in the space, all equally used, but in no particular order. A bit random, just like Mr. Nacho himself.

Lotta: What is your favorite tool?

Nachos: My pencils, particularly a thick navy blue.

Lotta: From where do you get inspiration?

Nachos: Everywhere. Moving to Stockholm has contributed to a more relaxed and sincere working method. The calm rhythm of life here, especially during the winters, has affected and inspired me. There are no colors or shadows for several months out of the year, so you have to invent them.

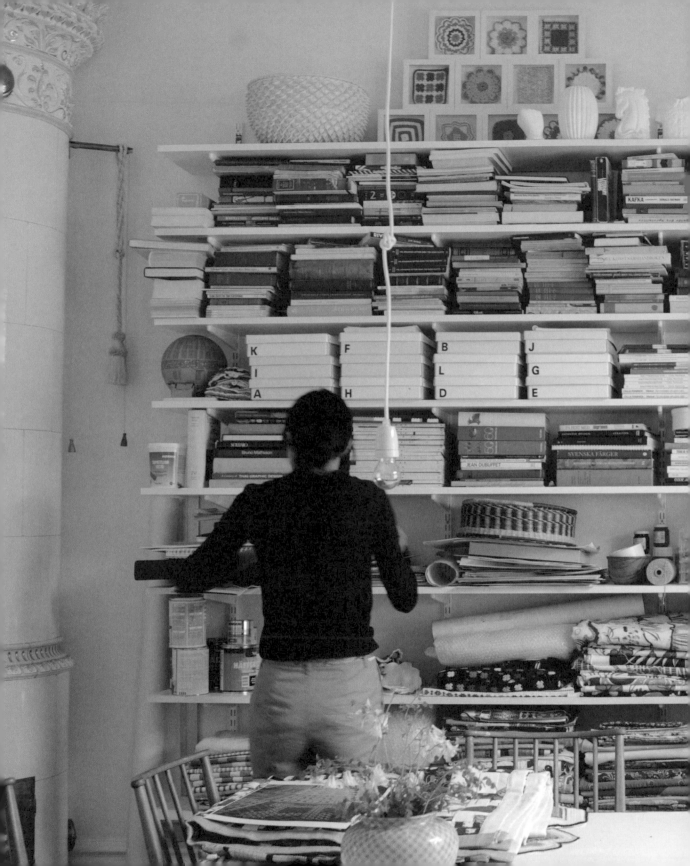

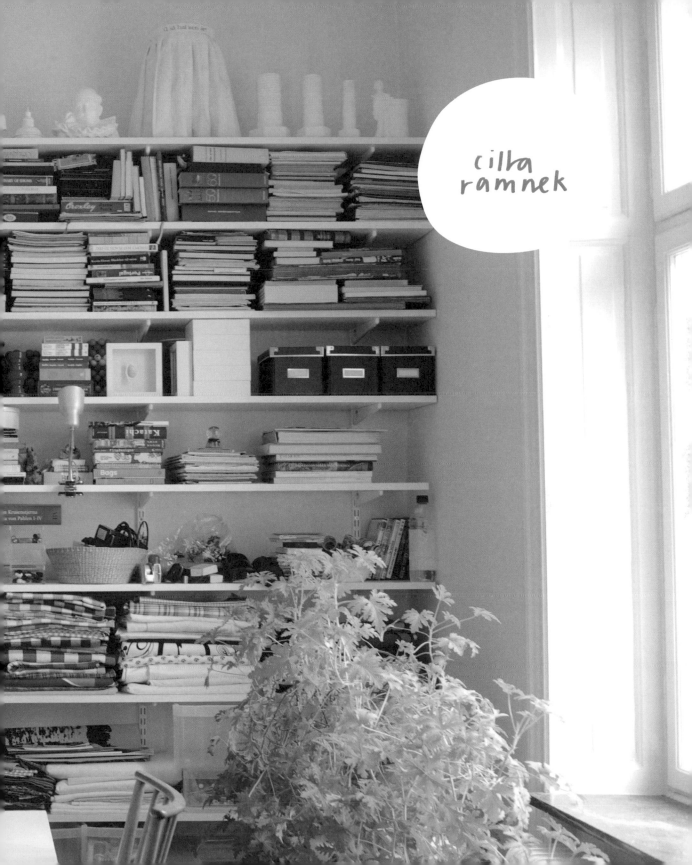

cilla
ramnek

Cilla Ramnek
Artist and designer
Studio size: Her whole apartment—1,399 square feet (130 square meters)
Time in studio: Five years

Jenny and I were panting heavily after we climbed the four flights of stairs up to Cilla's apartment/studio (yes, we're out of shape). We caught our breath before we rang the doorbell, but, when we were invited into the spacious five-room apartment, it took our breath away yet again (this time out of sheer excitement). What an incredible sight: her place simply vibrates with creativity, playfulness, and personal style. Every room was unique and had been approached with a keen sense of design; everything was decorated with wit and wisdom.

Cilla creates wherever she is. She is always thinking, always processing and "digging into piles of discarded junk," she says. I love how easy she makes it all seem. Her home is a very relaxed place and everything seems to come together naturally. She has a knack for mixing and matching pieces of different styles and still achieving a cohesive result.

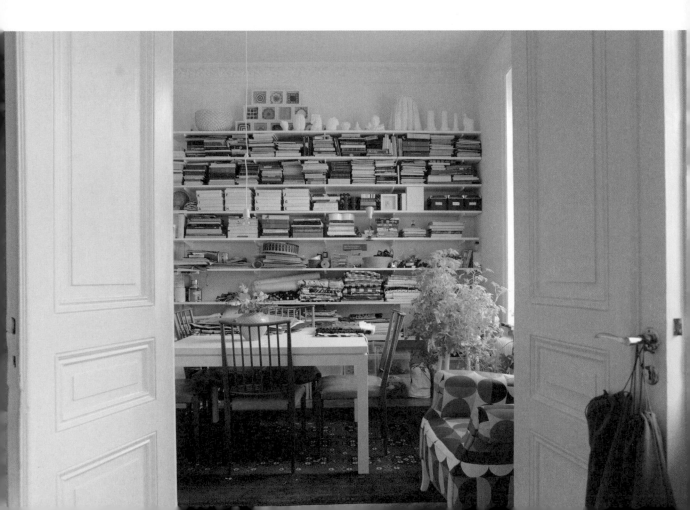

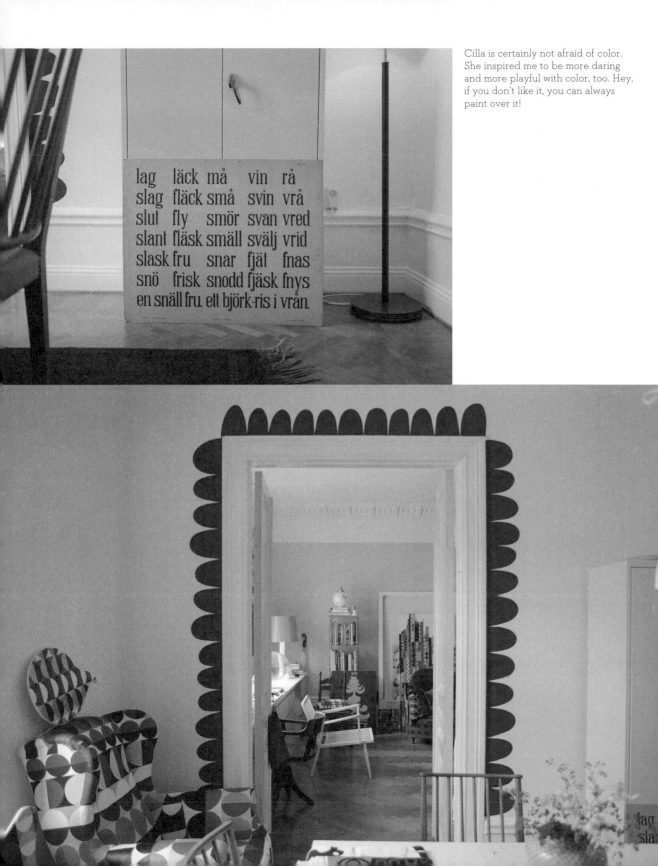

Cilla is certainly not afraid of color. She inspired me to be more daring and more playful with color, too. Hey, if you don't like it, you can always paint over it!

lag läck må vin rå
slag fläck små svin vrå
slut fly smör svan vred
slant fläsk smäll svälj vrid
slask fru snar fjät fnas
snö frisk snodd fjäsk fnys
en snäll fru. ett björk-ris i vrån.

Cilla displays all of her tools and materials on open shelves, keeping her books and supplies handy. I was so inspired by this that I decided to do the same in my new studio space rather than hide away all these wonderful things in drawers and cupboards.

Cilla's notebooks (opposite page, top left) are filled with sketches and ideas.

Even IKEA drawers (below) make it into the eclectic environment.

Lotta: What do you make in your studio?

Cilla: I sew, crochet, draw textile patterns and designs, create art pieces out of plastic beads, and write books, among many other things.

Lotta: How do you describe the style of your studio?

Cilla: I mix new with old so that it is seamless, so that nothing looks out of place.

Lotta: Where do you get your inspiration?

Cilla: From the work itself, from the process of actually doing something: something new and different is always happening here.

Cilla's textile patchwork fills the apartment, sharing the space with handmade wool pillows woven more than one hundred years ago.

I love how she framed this collection of hand-crocheted pot holders (above left).

STYLE: Tigh

Anna R

We

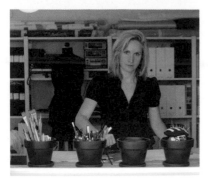

Anna Bonnevier

Clothing designer

Studio size: 194 square feet
(18 square meters)

Time in studio: A few months

We borrowed my good friend Tim's car and drove out to the suburbs of Stockholm to visit Anna, a women's clothing designer. She lives about twenty minutes from the city center in a town called Gustavsberg. The main reason she and her partner, Jerker, wanted to move here was to be close to Anna's mother, who could help take care of their children while Anna worked. Anna and Jerker are both interested in architecture and specifically sought out a house designed by the Swedish architect Olof Thursstrom. They found one that had been built in 1952 and kept it in its original design. Their home is a charming and functional split-level house with a separate unit facing the garden. They are currently making some small renovations to the third bedroom. The family lives upstairs, and Anna's studio is on the lower level of the house.

Anna creates clothing intended for women who have found their personal style; her pieces are artful yet wearable and functional. She creates collections based on ideas rather than on trends, which I love. Her black-and-white studio reflects the colors she uses most in her work. Her space is simple, practical, and very organized.

A visual inspiration board hangs on the studio door.

Samples, swatches, and projects-to-be are housed in beautiful vintage suitcases in the storage room (opposite page, bottom right). I love this idea.

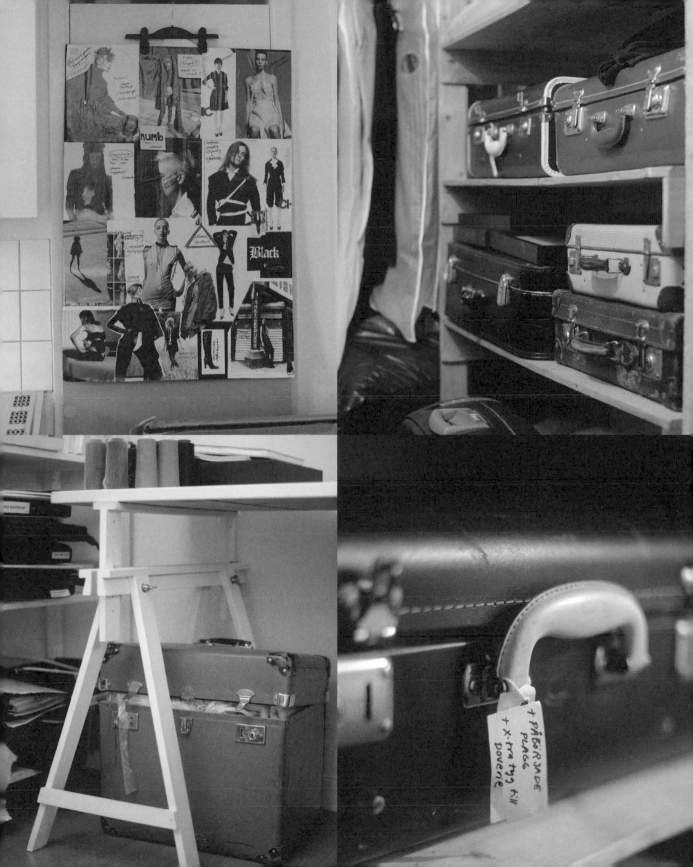

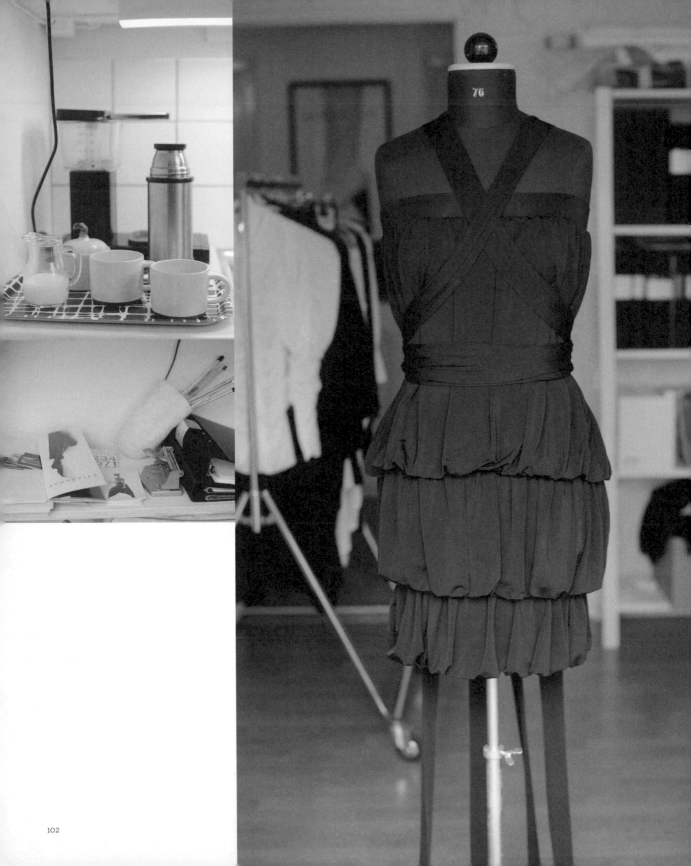

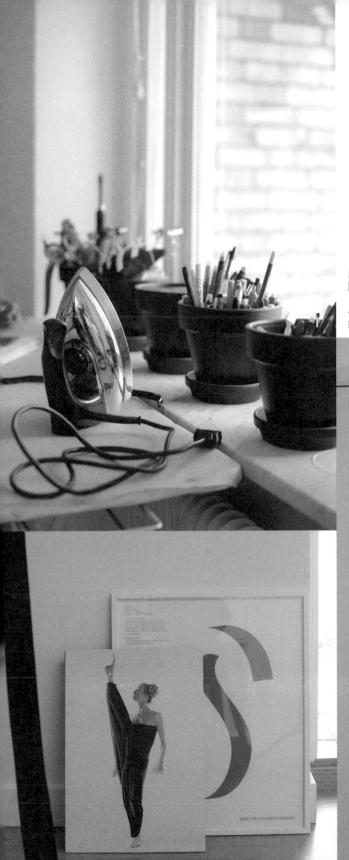

Hot *kaffe* was ready for Jenny and me in the studio's small pantry kitchen when we arrived.

Anna stores pencils and tools in terra-cotta pots, which she painted black.

Lotta: What is your favorite time to work in the studio?

Anna: During the day from nine in the morning to three in the afternoon—that's when I am the most alert.

Lotta: What do you make in your studio?

Anna: I create clothing and I also like to write. At night, I'll fill books with thoughts about my design work, process, and other philosophies that inspire my work.

Lotta: What is your favorite tool?

Anna: My pair of scissors.

Anna's home is upstairs, but her kids often come and visit their mom and play in the garden close by while she is working.

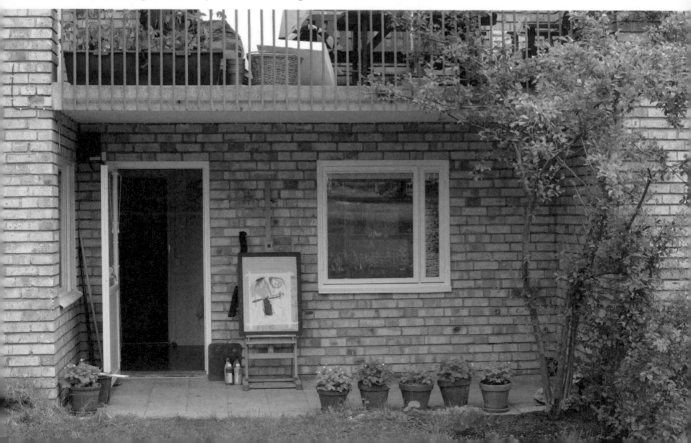

Anna keeps family heirlooms around her studio for inspiration, like this white squirrel fur piece (above) which used to belong to Jerker's grandmother.

Anna covered this old, handcrafted heirloom chair (below) with cozy sheepskin, a very popular textile in Swedish homes.

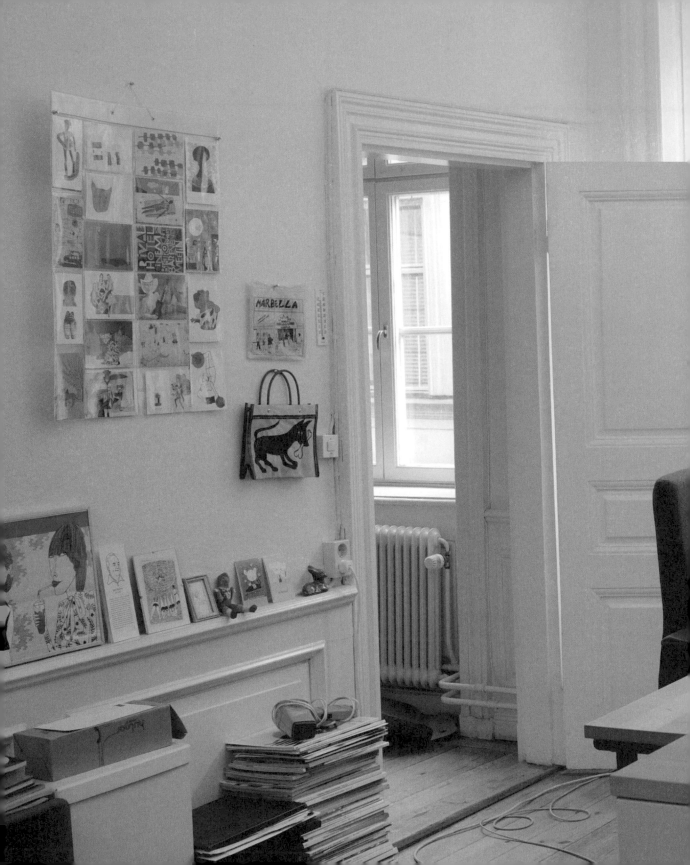

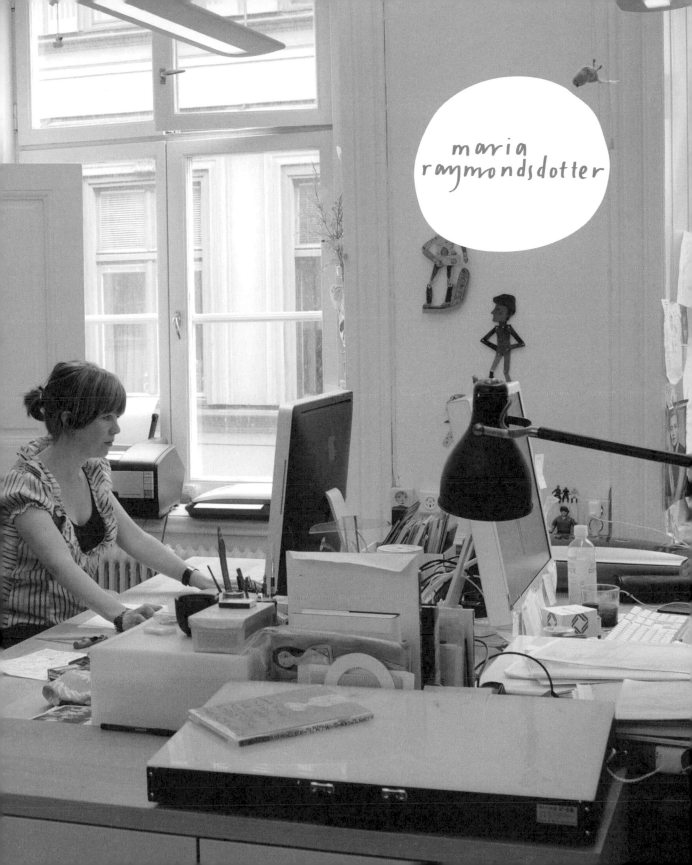

maria
raymondsdotter

Maria Raymondsdotter

Illustrator

Studio size: The entire space is about 1,076 square feet (100 square meters). Maria's room that she shares with three other people is about 215 square feet (20 square meters)

Time in studio: Eight years

Maria is a born illustrator. I met her on our first day of school, at age seven, and as long as I have known her she has sketched kooky characters and funny figures. Her illustrations have adorned book covers, biscuit packaging, store displays, advertising campaigns, and many different magazines, and they have even been animated.

Maria rents a desk in a space she shares with nine other illustrators. The office is located in a seventeenth-century building in Stockholm's Old Town area. Everybody in the group works independently, but they are also available to share ideas and offer input on projects, which Maria finds helpful. She treasures socializing with her peers and finds that working in a group environment also helps her to be disciplined with her own work: if you go to an office where everyone is working, then you are motivated to work as well. Just like roommates, they share costs such as DSL, phone, and cleaning and kitchen supplies. They also exhibit together at book fairs, send out joint marketing materials, and once in a while take a coffee or lunch break together.

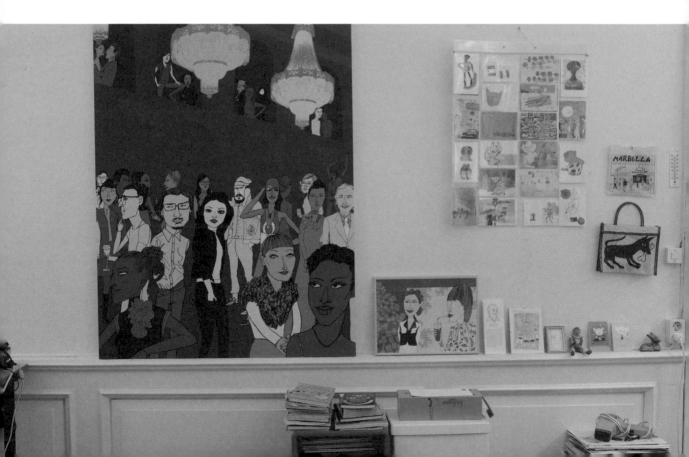

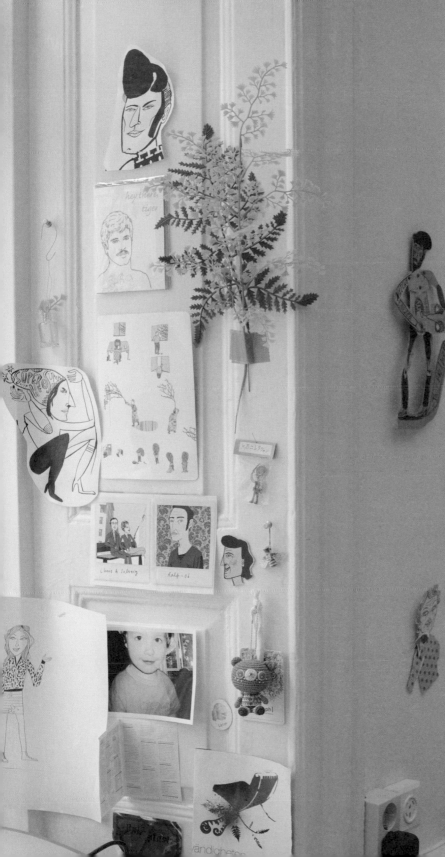

Marta hangs recent work and bits
and pieces of inspiration on the wall.

Magazines are a very important source of inspiration for Maria; she clips and keeps many images in notebooks.

In this shared common area (opposite page, bottom left), the illustrators lounge, hold meetings, and occasionally take naps. Maria and I sat down for a chat about the space, her process, and her office mates. I love how they use the old ceramic wood stove as a bulletin board (at right of frame); it's cluttered with sticky notes!

Some of Maria's illustrated characters hang out in cardboard storage boxes (above).

Lotta: What do you like most about your studio?

Maria: It's in a very central location in the city. It's just a beautiful fifteen-minute bike ride along the water to get here from my home.

Lotta: What, if anything, would you like to change about your studio?

Maria: I wish I had more tabletop space, so I could spread out my work and papers away from the computer.

Lotta: When is your favorite time in the studio?

Maria: In the afternoon. I am pretty slow moving in the morning.

Lotta: Tell me three things you love about working in Stockholm.

Maria: Stockholm is big enough to have everything a capital city has to offer, yet it is very accessible. Interesting places are right within reach, and you can cycle everywhere in safe, well-constructed bike lanes. I also love being near the water! Stockholm is built on fourteen islands, with a fantastic archipelago with more than thirty thousand islands, islets, and skerries. It is a perfect combination of city and nature. Sometimes in the summer, I eat my lunch on a jetty by Lake Mälaren. Also, Swedes are good at keeping up to date with trends, fashions, and culture from around the world, which makes Stockholm an interesting melting pot of music, design, and ideas. As a designer and illustrator who loves inventive and playful work, I find this to be a great place to work and live.

Maria blow-dries a drawing before she scans it for a final computer illustration.

Maria first draws her illustrations with pen and ink, using special nibs.

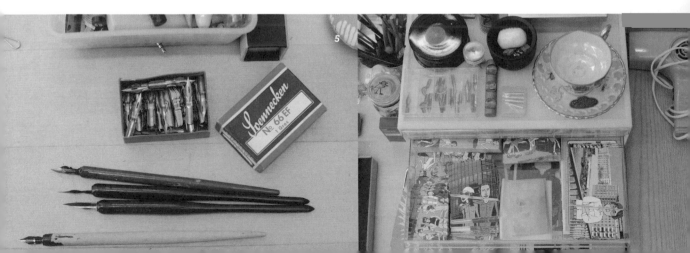

Anna Broström

Ceramic artist

Studio size: 377 square feet
(35 square meters)

Time in studio: Five years

I first spotted Anna's ceramic work in a small clothing boutique in Stockholm a few years ago. I was drawn to the wonderful patterns and colors. After that, I began seeing her designs all over, in unique and interesting shops.

Anna started making her ceramic cups and bowls in 2002. She has always been interested in patterns, fashion, and decor—interests that are very visible in her work. Her ceramic pieces look like they are covered in textile prints, mostly inspired by nature and what she sees happening in the fashion world. Anna works part-time at home in her small and cozy apartment and part-time in a shared ceramic space, where she fires the pieces.

Anna's technique for making these ceramic pieces is rather remarkable: The whole creative process starts at home on the couch, where she uses her laptop to search for motifs and patterns. Once she has decided on a motif, she traces it onto regular notebook paper and then cuts out these prints by hand, one by one, into stencils.

She needs to cut out at least one stencil for each ceramic piece (more if she plans to have more than one color variation on the ceramic piece), so she spends many evenings in front of the telly, cutting for hours. The designs are intricate and small, which makes this very tedious work—I'm amazed by Anna's patience. She then uses the stencil to apply the glaze to whatever she is making, which means that she can only use a stencil once. The result is a unique, beautiful piece every time. Being a textile designer myself, I love the organic motifs and color palettes she uses.

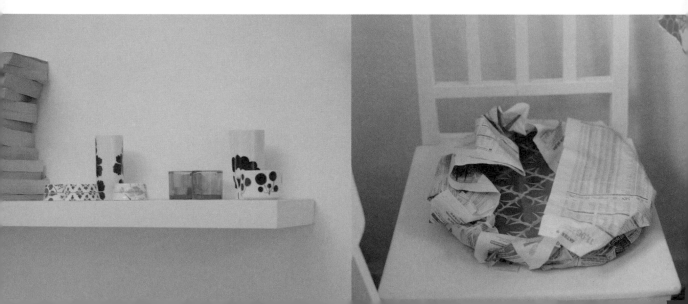

...na's little apartment is filled with her ceramic bowls, plates, and cups.
... where she stores her inventory and packs up orders for delivery.

Under the couch, we found two plastic bins filled with treasures:
Anna's ceramic samples and extras (below). I now own six of
Anna's latte mugs, and I don't even drink lattes!

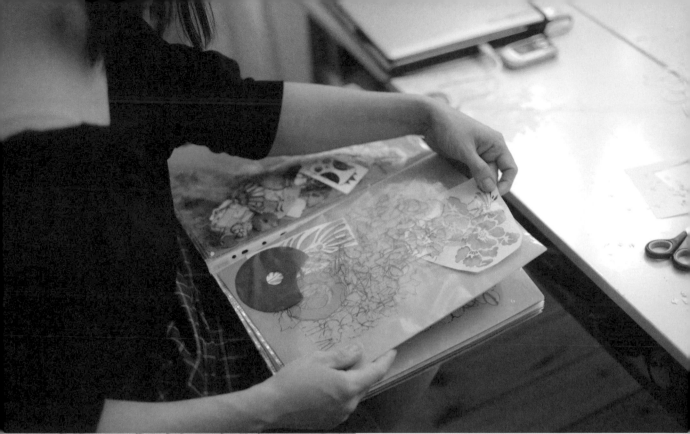

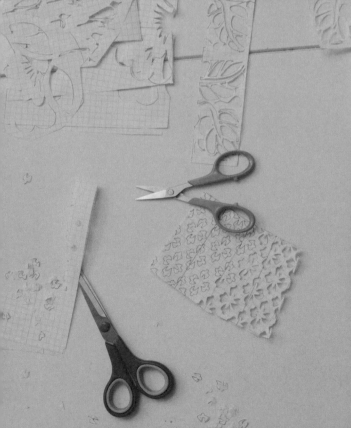

Anna stores her paper templates for each design in a notebook.

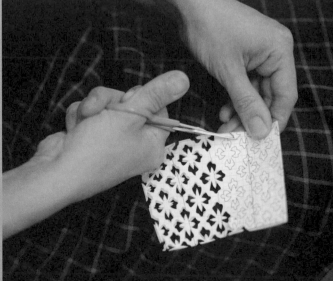

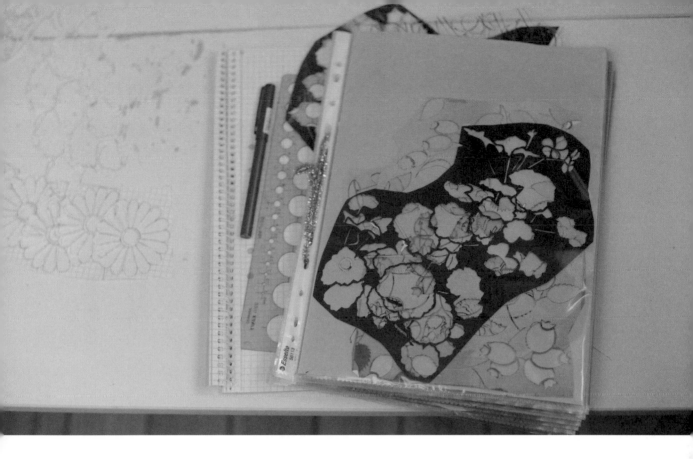

Lotta: What is your favorite time to work?

Anna: My favorite time to create is around eleven in the morning to three in the afternoon. This is when I am most focused and have the most energy.

Lotta: What do you like most about working from home?

Anna: That I can work from my couch while watching TV!

Lotta: What do you like least about working from home?

Anna: That it is hard to have your free time. There's always work to be done, and I don't have that separation of work and home.

Lotta: What does the word *inspiration* mean to you?

Anna: *Inspiration* to me is that feeling of excitement and urgency. When I'm inspired, I can't wait to go to my studio and get to work on my new idea.

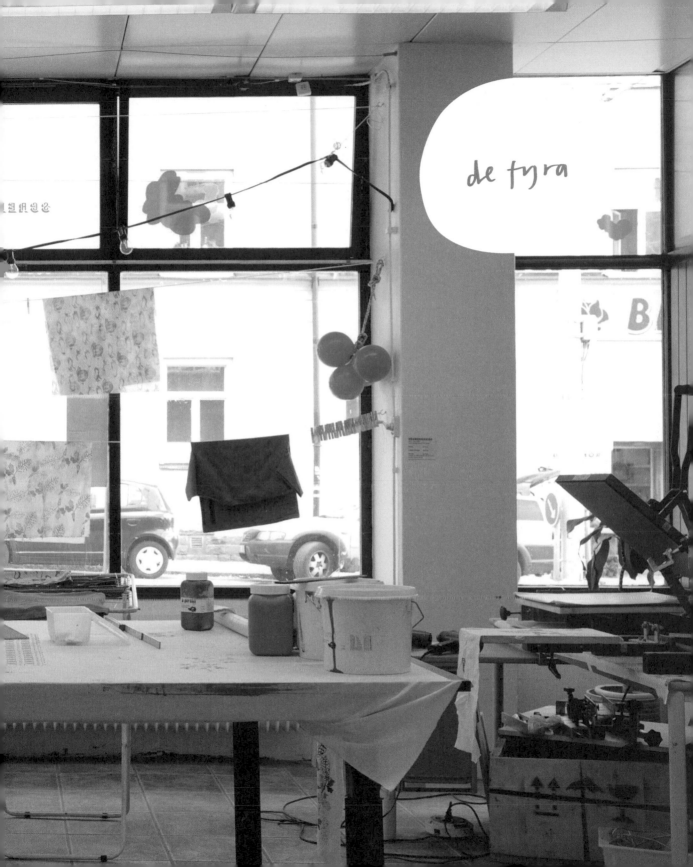

de tyra

De Fyra

Studio size: The shop is about 323 square feet (30 square meters) and the workshop is about 1,819 square feet (169 square meters)

Time in studio: Five years

Sanna Haverinen, one of the four members of the design group De Fyra, greeted us with open arms, delicious butter cookies, and lots of show-and-tell when we arrived at the light-filled showroom where De Fyra sells its products and designs. What a sunny and happy place! They wound up there because the designers, looking for a studio, were the first to answer a private ad about the space back in 2006. But they quickly outgrew it and moved their production and studio activities to another, much bigger space, reserving the first spot for their showroom.

After the tour, we hopped in a cab and drove off to De Fyra's big studio space (which they share with another screen-printing supplier) in the suburbs of Stockholm. On the way, I asked Sanna about inspiration and how she finds it. Her answer: "I cannot simply sit down and think about things to make and bring forth new creations. It's when I start doing something with my hands that the process actually happens—out of that, something new will begin and evolve." Sanna and the other De Fyra designers, including Anna Lång, Lena Thak Karlsson, and Anna Hjert, started working together about six years ago. Sanna continues, "It is fun to work together. We share our opinions, and we combine and share ideas with each other. It all comes together as a whole in the end."

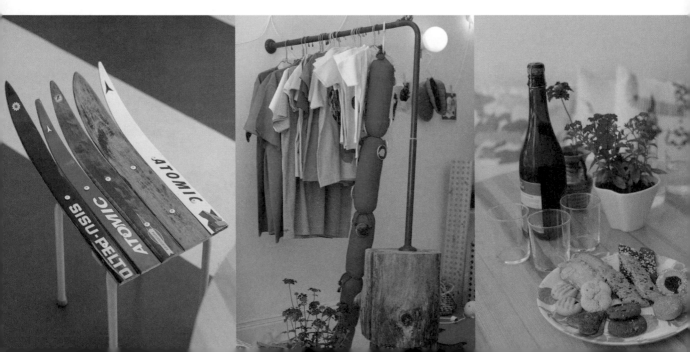

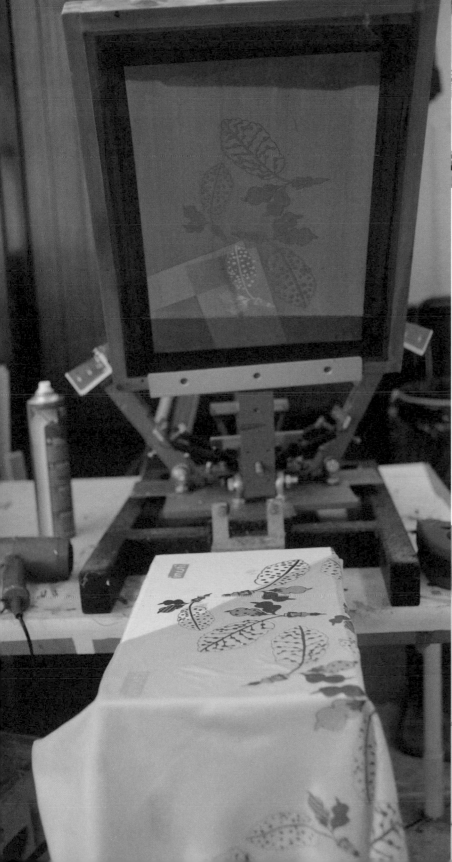

Opposite page, left: Samples of work, like an end table made from old skis and a rack of colorful T-shirts (and I had to share those delicious cookies with you as well), were a few of my favorite things from the De Fyra showroom.

This page shows three different techniques used in hand-screened production. De Fyra also offers easy screen-printing workshops in their space.

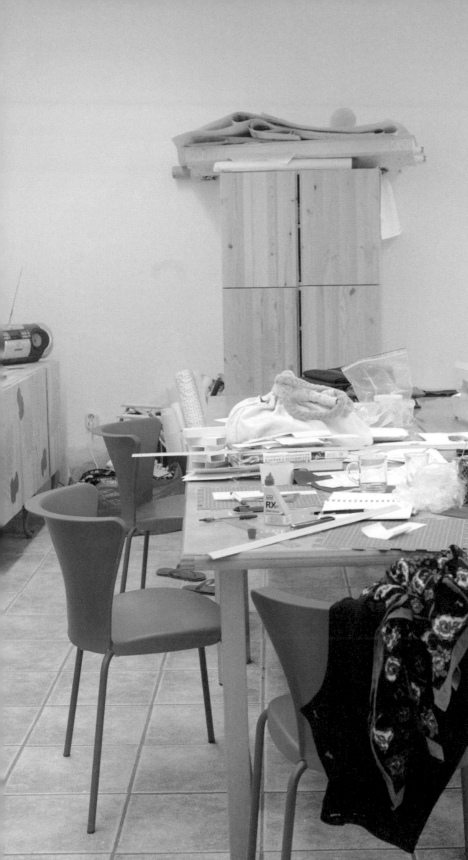

Most of the furniture was already in the space when they moved in. They also adopted some from the screen-printing company that shares the studio. I love the easy and relaxed approach De Fyra seems to have when it comes to process. There are many different worktables set up in the studio, most with unfinished projects waiting to be completed. No need to put everything away—they simply drop it and pick it up again at a later time.

This simple wood console (opposite page, bottom) used for storage becomes a one-of-a-kind piece with the help of some stencils. And that blue IKEA tote is a true classic. It will store and carry almost anything!

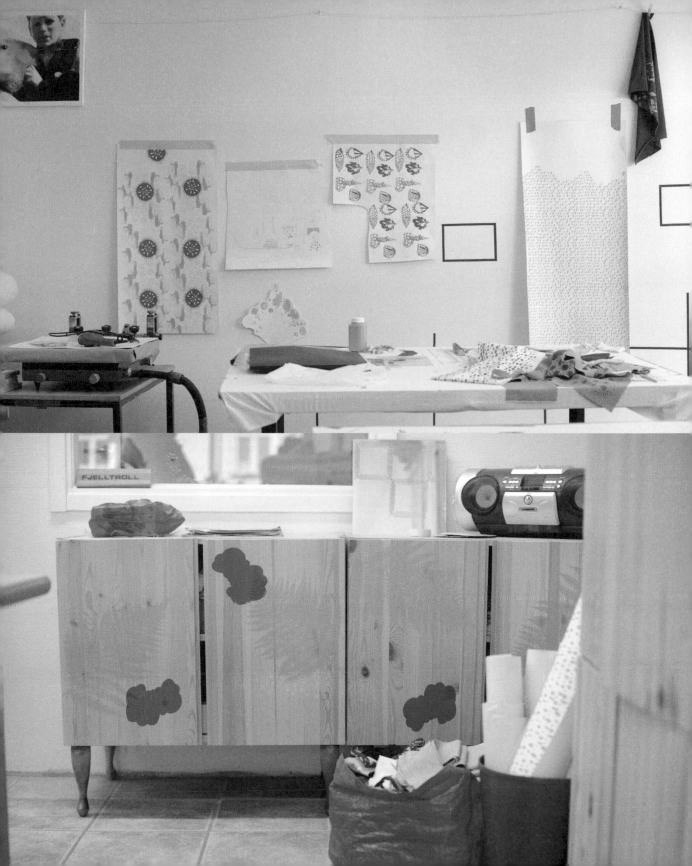

Lotta: What do you make and create for a living?

Sanna: Our design group works with and explores different materials. We have our own production of fabric towels, T-shirts, and wallpaper.

Lotta: Do you listen to any music while you work?

Sanna: Yes, a lot! It's especially nice to listen to a good mix of songs, from Etta James to the Knife.

Below, interns are at work on a project.

Large closets serve as storage space. There's nothing fancy or complicated here, just simple furniture that they fill with materials and supplies.

Many of the designers bike to work every day; Stockholm is a very bike-friendly city.

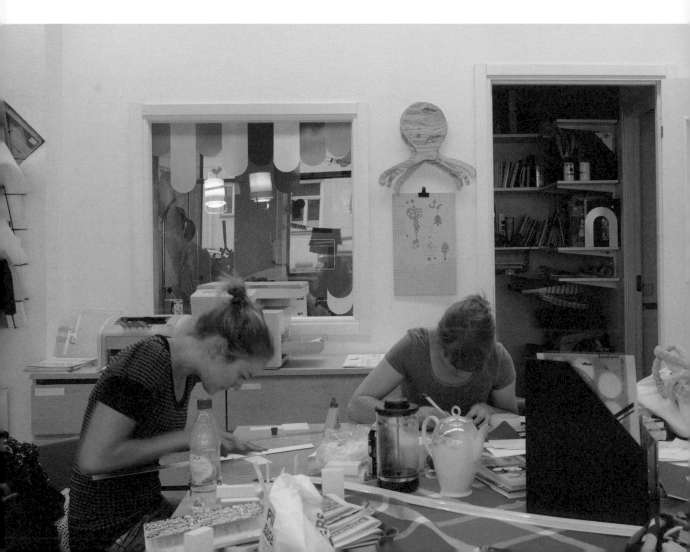

129

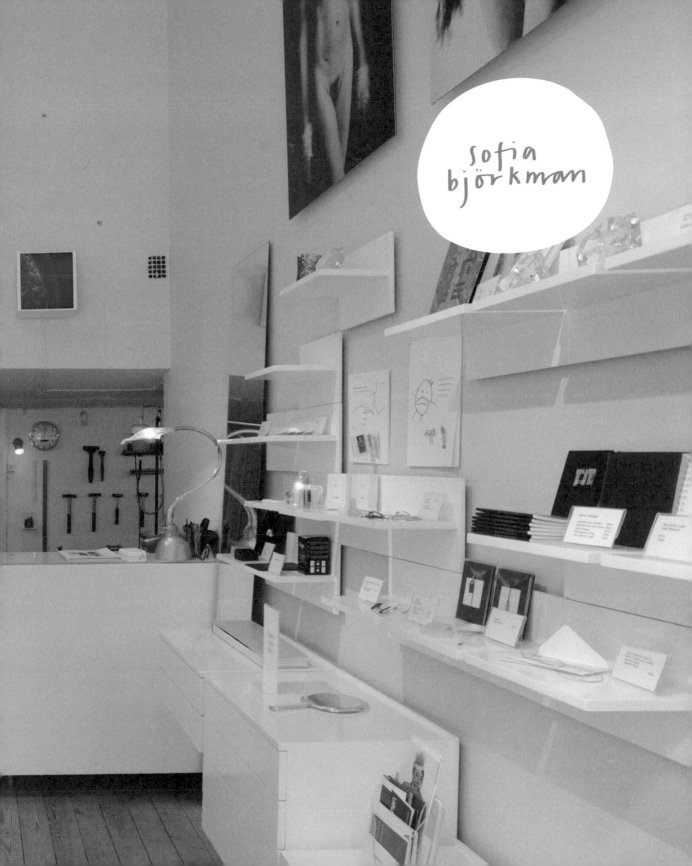

sofia
björkman

Sofia started her own business right after she graduated from design school in 1999 and has found that combining her creating and selling spaces works really well for her. When the flow of customers in the shop is slow, she can work in the back on projects. The store functions, well, as a store, but also as a gallery for many different jewelry designers. Sofia curates several shows a year and invites designers from all over the world to participate.

She enjoys the emotional connections she makes in her business. People come in to buy jewelry for special occasions or as gifts for weddings, birthdays, christenings, and so on. There is a lot of joy and excitement involved in buying those special-occasion pieces, since they will remind people of that important time in their lives for years to come.

Sofia Björkman
Jewelry designer
Studio size: 538 square feet
(50 square meters)
Time in studio: Nine years

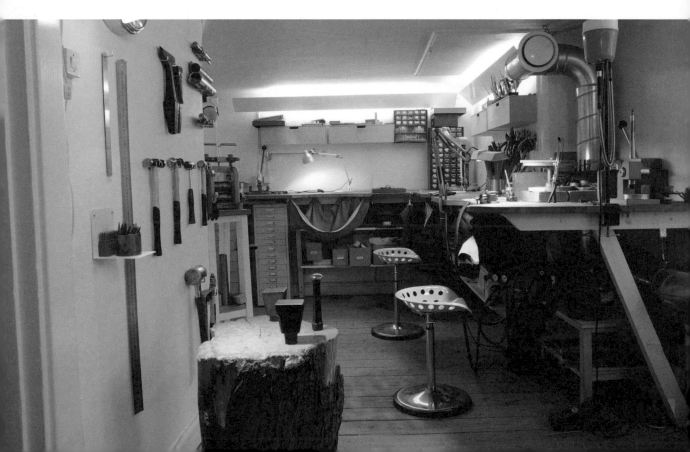

Cost-effective IKEA storage cabinets share the space with custom-built workbenches. It's really important to get the correct work height for jewelry design, since the designer spends a lot of time standing or sitting in the same position.

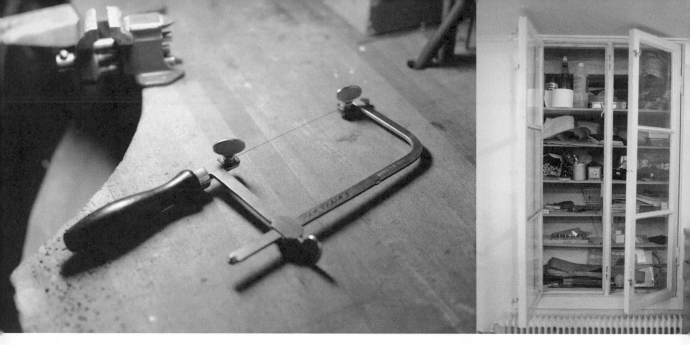

Sofia says that, for her, it is much easier to work if she stays organized and keeps up with the cleaning after she completes a job. These clear bins and metal filing cabinets (below) keep clutter hidden and organized.

Sofia's favorite tool is the goldsmith's saw (above left) but this built-in storage cabinet (above right) is crammed with even more tools. The doors are made out of salvaged window panels, which I thought was a clever and unique way to repurpose a window into something useful and visually exciting.

Sofia's neighbor at her country house, a farmer, helped her get this nice solid wood stump (opposite page) to use as a place to set tools.

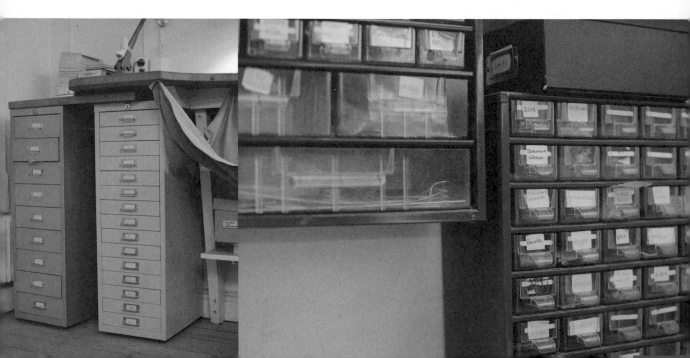

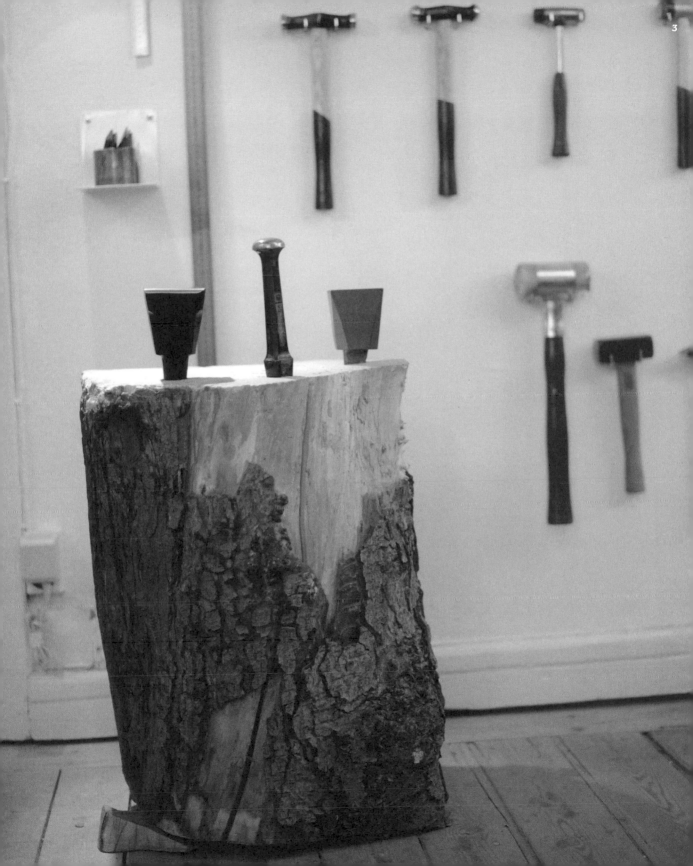

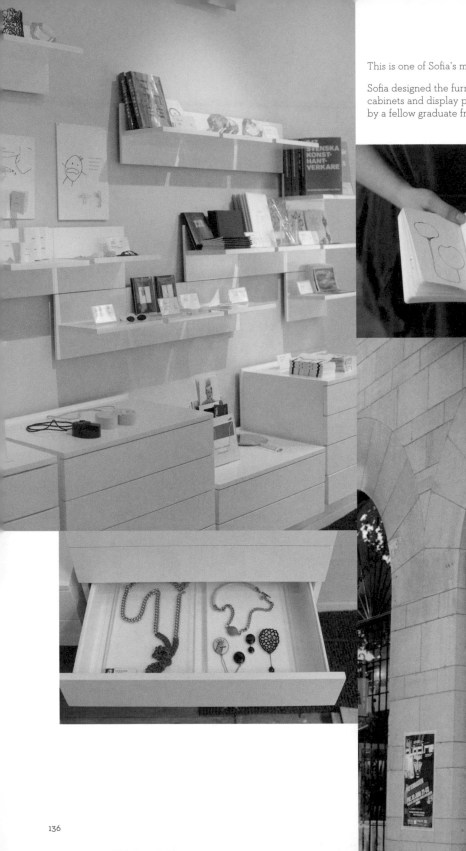

This is one of Sofia's many sketchbooks (below).

Sofia designed the furniture in the store. The cabinets and display pieces were custom built by a fellow graduate from design school.

Lotta: What do you like most about your current studio/shop?

Sofia: I enjoy that I can mix the social aspect of meeting customers and people with my work.

Lotta: What do you listen to while you work?

Sofia: Radio. My favorite station is called P1. It is intellectual radio with a lot of talk. Philosophical programs are the best. I also listen to a lot of hard rock—yeah!

Lotta: What inspires you in your designs?

Sofia: Everything is inspiration, really. The work itself also inspires me. While I am in the process of making something, other new designs and ideas form, and I jot those down in my sketchbooks.

Lotta: What is the most fun thing about being a designer?

Sofia: It is so fun when I can create a "flow"—when I free all of my senses and let wacky and crazy ideas flow through my mind and then transfer them onto materials. There is a lot of creative freedom in being a designer.

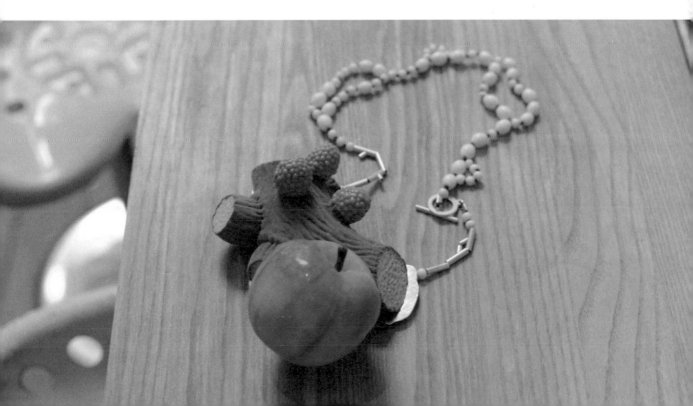

tokyo

How many times have I traveled to Tokyo? I'm guessing maybe fifteen or sixteen—I can't remember exactly. But I keep wanting to go back.

I am so incredibly fortunate to have close connections and friends in Tokyo. The city simply amazes me every single time!

Tokyo is an extraordinary city where ancient traditions coexist with the ultra new and futuristic. While walking the streets of Tokyo, you see outrageous fashions, fancy cars, and technology mixed with Zen parks and strolling geishas.

Tokyo is packed with people: space is small, be it a parking lot, a café table, or an advertising slot in the paper. Of course, this means studio spaces are small as well.

During our Tokyo studio visits, Jenny and I often encountered challenges with space. On several occasions, we simply could not capture an entire area with the camera, because the space was too small. More than once we had to cram ourselves, gear, and translators into small corners and crannies. But what the Japanese lack in space, they make up for in organizational skills: they really know how to maximize space and keep things stacked and tidy. In these studios, almost everything has a place. Similarly, I find that many of my Japanese friends and acquaintances are incredibly detail oriented and hard working. (I wish this tendency would rub off on me somehow!)

For artists or designers, traveling to Japan, and Tokyo specifically, is a must. It is a visual country in all aspects: illustrations are used for many different purposes, food presentation is artwork in itself, and the fine details everywhere you go are impeccable. After a trip to Tokyo, your inspiration books will be stuffed and the memory card for your camera will be completely maxed out.

If you cannot go anytime soon, maybe a virtual visit to some of these studios in the following pages will satisfy (or hopefully pique) your interest.

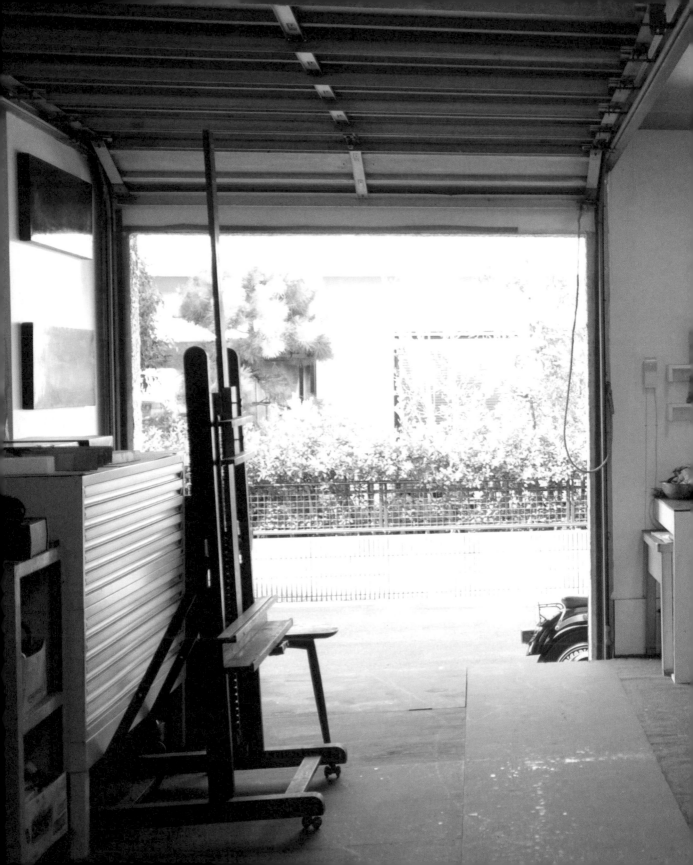

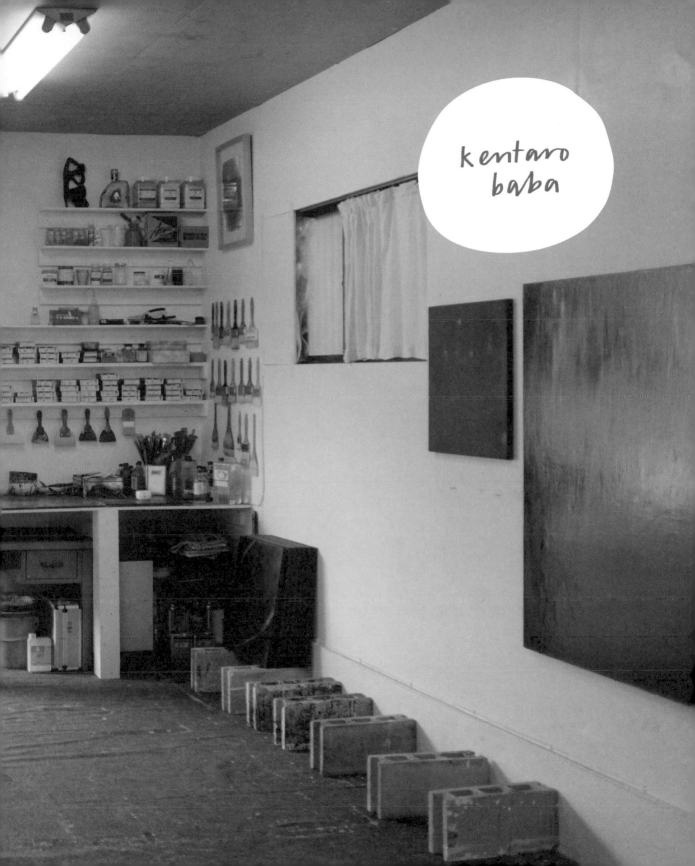

kentaro
baba

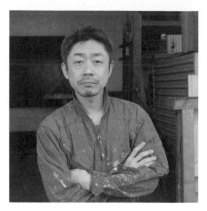

Kentaro Baba
Painter
Studio size: 646 square feet
(60 square meters)
Time in studio: Six years

I met Kentaro the first time I visited Tokyo, in 1999. I vividly remember having passionate conversations with him over dinner, talking about his art and his vision, his paintings and inspiration. He speaks only Japanese, and I speak only Swedish and English, and neither one of us understood a word the other was saying, yet, somehow we bonded over this conversation. (It didn't hurt that we both love beer.)

Kentaro lives and works about an hour's drive from the city center. He lives close to a big park, and his studio is surrounded by calm neighborhood streets—a very different pace than that of the bustling city center. Kentaro, a working painter for fifteen years, creates large-scale oil paintings in his spacious studio, which is actually a converted garage—the larger space works well for his oversized paintings. The rent is affordable since it's located away from the city center, and if he needs to meet with clients or buy supplies, he just hops on his motorcycle and rides into town.

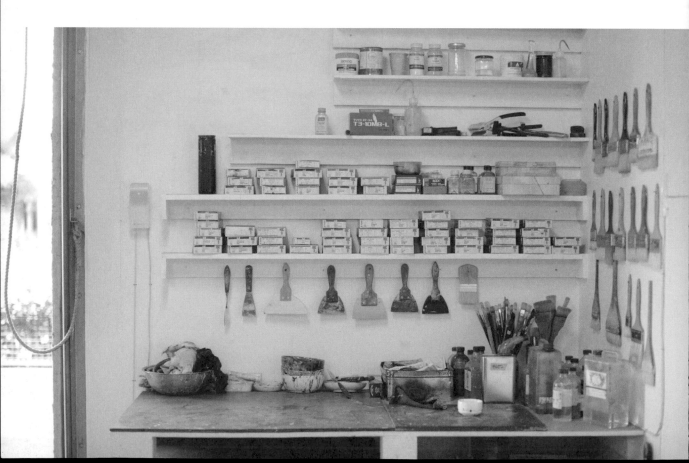

Kentaro custom built these clever storage solutions to hold all of those oversized supplies.

Kentaro is a rather organized painter, I must say!

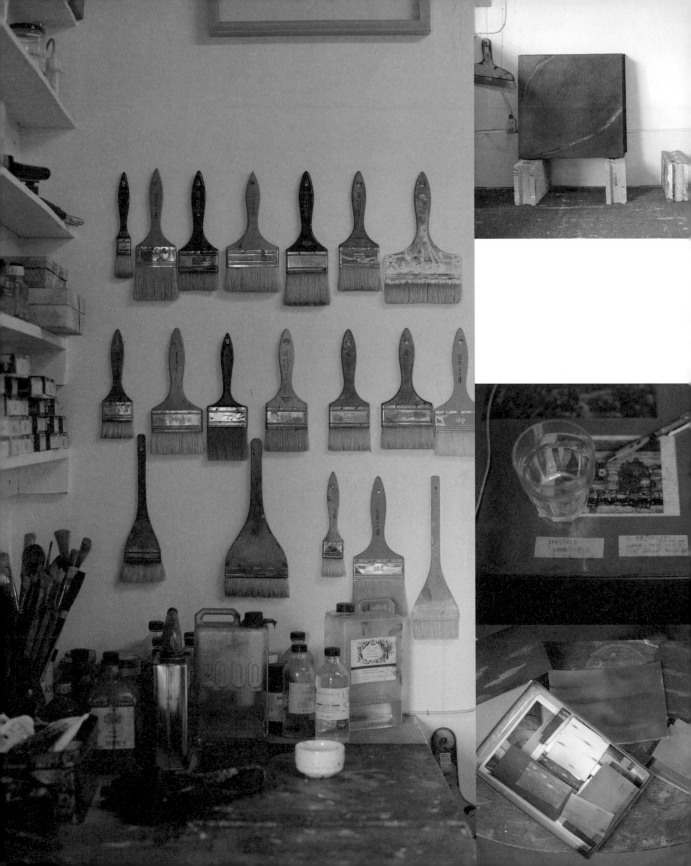

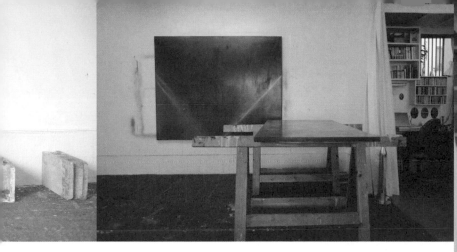

Kentaro uses brushes made out of Italian pig bristles. He has created simple and very useful drying stations (above) from cinder blocks. He simply props his canvases on them to allow the paintings to dry.

Kentaro stores sketches and drawings in photo paper boxes in a flat filing cabinet (below).

Lotta: What three things do you love about your studio?

Kentaro: It is big enough that I can put a large canvas on the floor and work. There are woods and a pond near my studio, and I can easily go for a walk to change my mood or get inspiration. There is a big shutter door, so it is easy to move big works out and in.

Lotta: What is your favorite tool?

Kentaro: My mixing knife, also called a painting knife. Mixing paint is really important in order to get the right colors for my work.

Lotta: Do you listen to anything when you create?

Kentaro: Italian opera and classical music, lots of it.

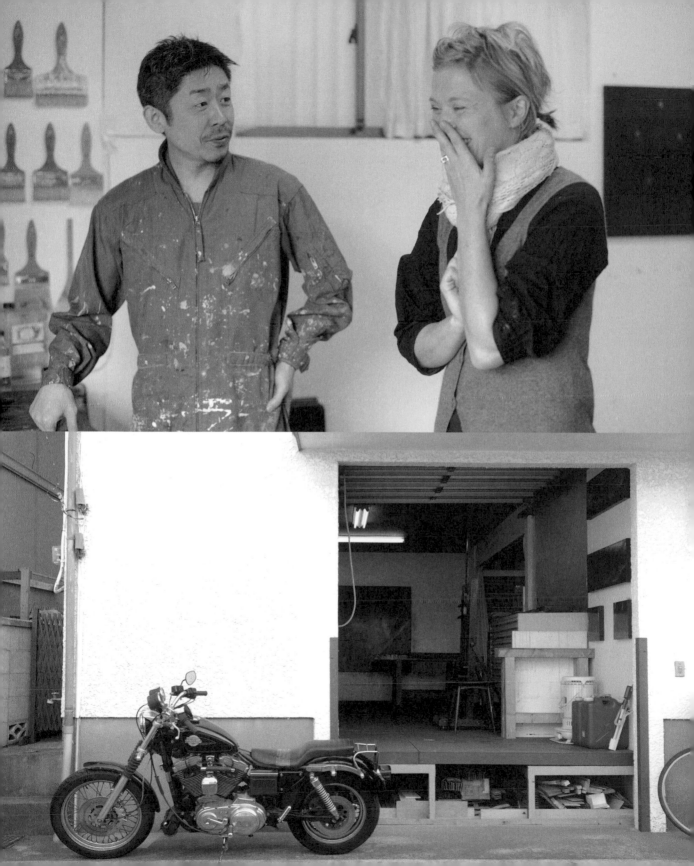

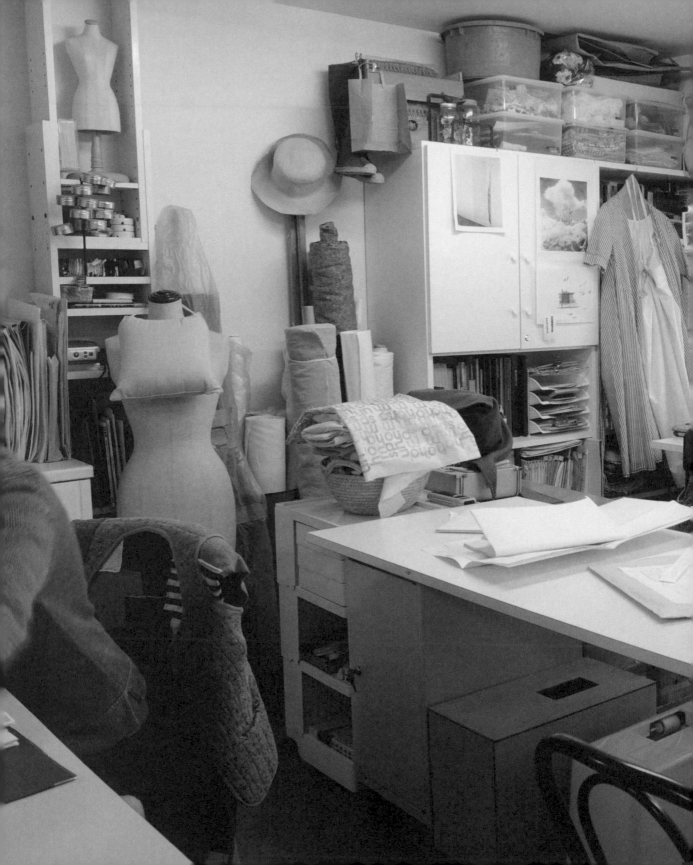

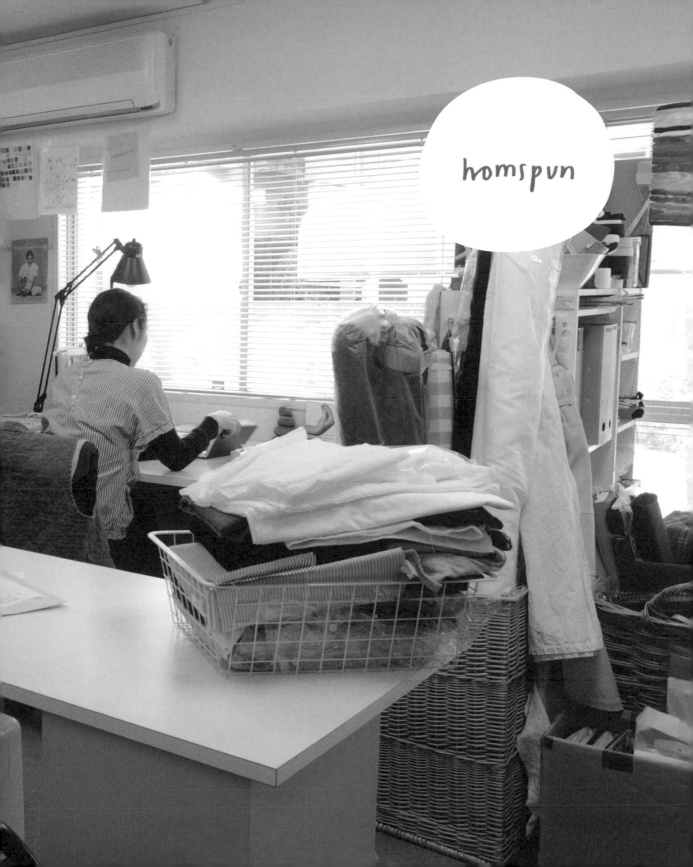

homspun

Keiko Hara. Hiromi Sakamoto.
Hiromi Kai. Yoko Yamamoto.

Designers, Homspun

Studio size: 355 square feet (33 square meters) [atelier]; 312 square feet (29 square meters) [office]

Time in studio: Eight years

The creation of Homspun's line of casual wear takes place in two offices next door to each other and a store in the Shibuya neighborhood of Tokyo. The owners moved into the first office back in 2000 and expanded into a second one three years later. One office is used for planning products and office work, and the other functions as sample and product storage and has room for a lunch table. The spaces have very different moods—some are messier and more creative, and some are more businesslike and organized—and it is nice for the designers to have that change in pace. The shop, where they sell their designs, is much more professional and concept driven—still very creative and free, but simply more official looking. I found the studio and office spaces to be very unpretentious and straightforward, not overly ornate, yet all over the spaces you find little traces of inspiration and creativity.

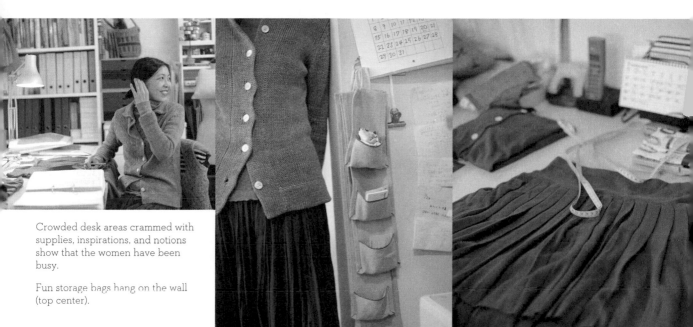

Crowded desk areas crammed with supplies, inspirations, and notions show that the women have been busy.

Fun storage bags hang on the wall (top center).

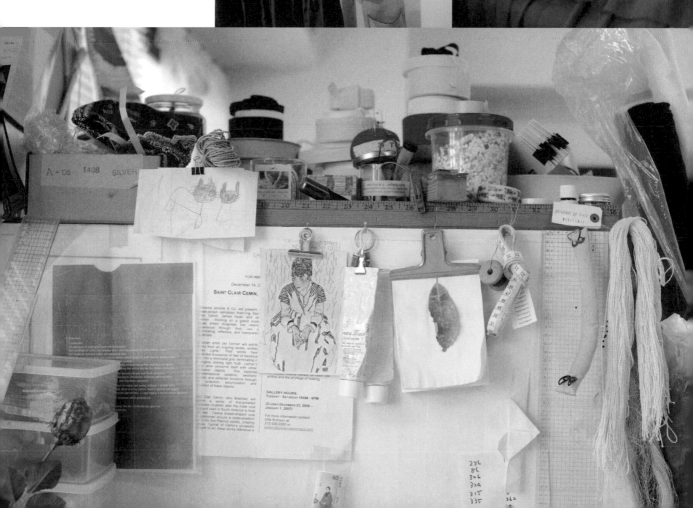

The designers make great use of this green metal door by covering it with magnets (below).

I was struck by all the different kinds of shelving and storage solutions at Homspun. My favorite: simple cardboard boxes that they painted white (opposite page, bottom right).

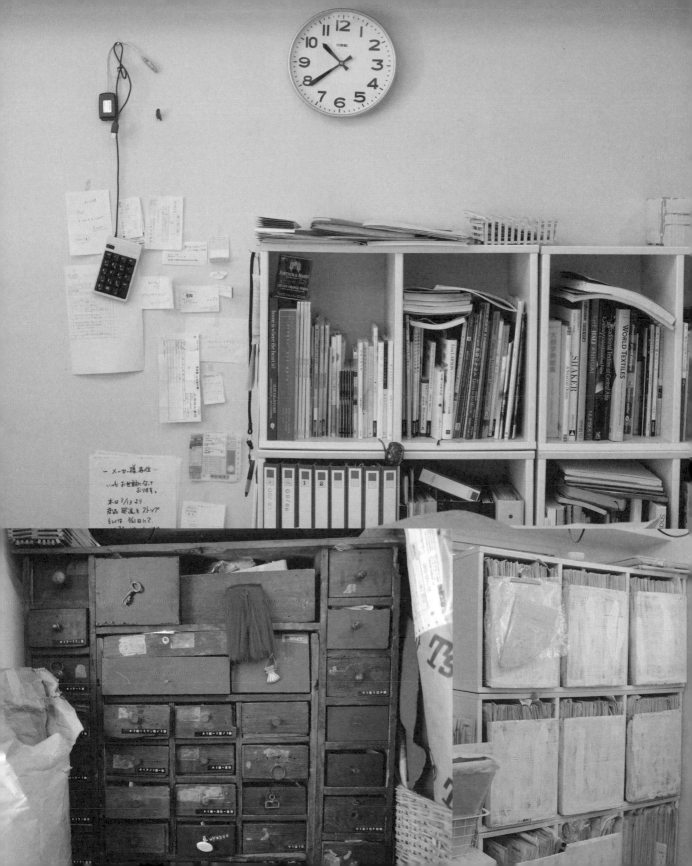

Lotta: What do you like the most about your studio?

Homspun: It's located next to a walking path so there are no cars outside; it is nice and quiet. We also love that it is very close to Tokyo Hands, a fantastic craft store.

Lotta: What do you wish you could change about your space?

Homspun: We need a bigger space, and we need to extend the kitchen area. It's pretty crammed!

Lotta: What are three things that keep surprising you about Tokyo?

Homspun: It is a super convenient city; we can buy everything in Tokyo! We have many bus and subway lines—it is easy to get almost anywhere in the city. It is difficult to find a quiet area in Tokyo, but our office is in a surprisingly quiet area.

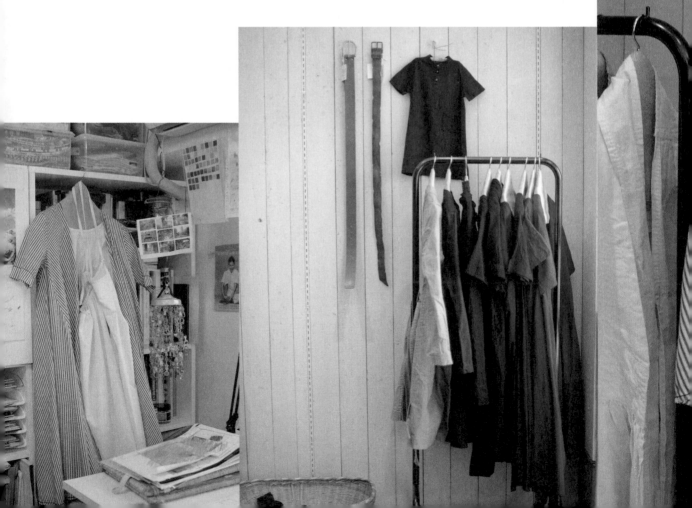

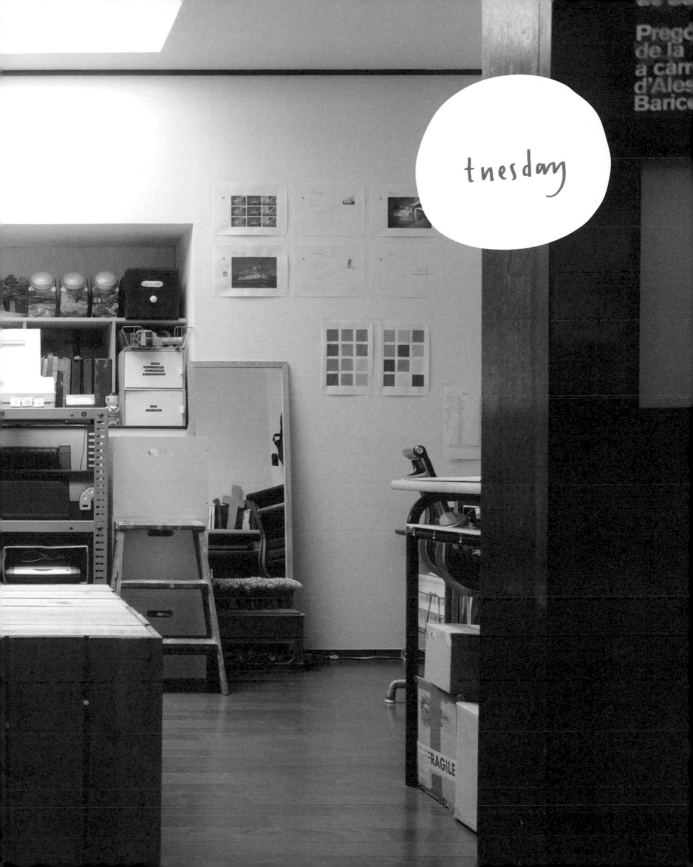

tuesday

Tomo and Chiyo Togawa

Founders of graphic design company Tuesday

Studio size: 108 square feet
(10 square meters)

Time in studio: Almost three years

I have worked with husband-and-wife team Tomo and Chiyo for more than six years now. They make up my graphic design team and have worked with me on several books, flyers, packaging designs, Web sites, and many more projects. We met in San Francisco in 2003 when we all still lived there. They had just started their own design company, Tuesday, and I was thrilled to work with them. They have a unique style and are extremely organized, fun, and super nice. They "get" me and my style.

Soon after they moved back to Tokyo, Tomo and Chiyo discovered they were expecting twins. They decided to find a place to live where they could raise a family as well as have room for their small, but growing, business. They found a charming split-level apartment at the end of a cul-de-sac, off a busy Tokyo street. This is where they raise their children during the day, and where they create graphic design magic at night.

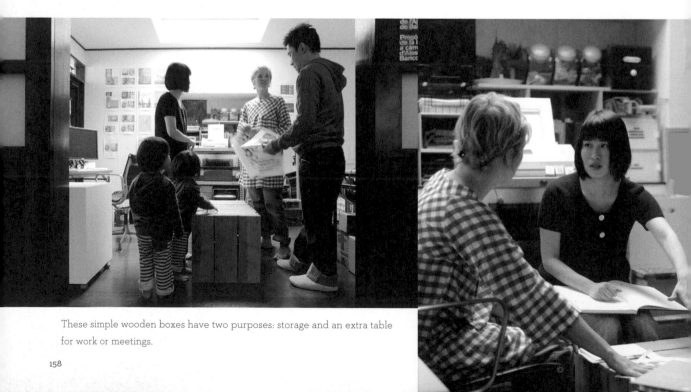

These simple wooden boxes have two purposes: storage and an extra table for work or meetings.

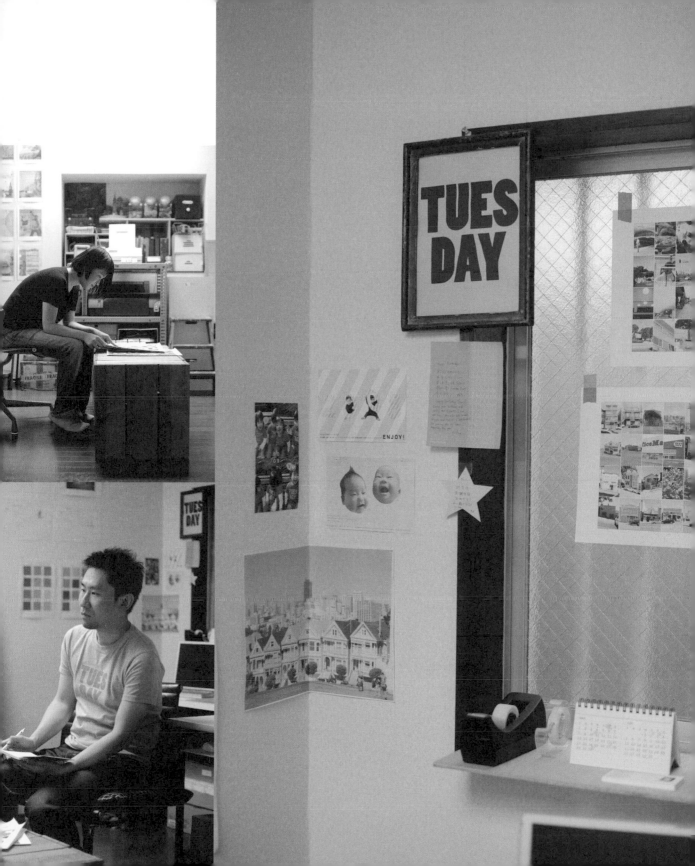

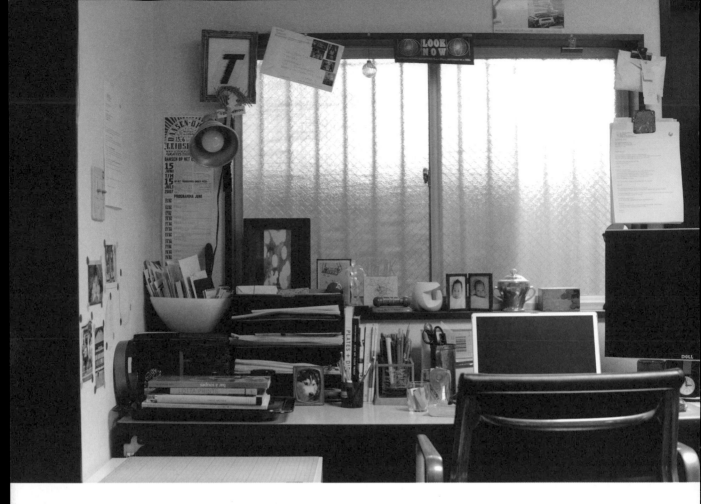
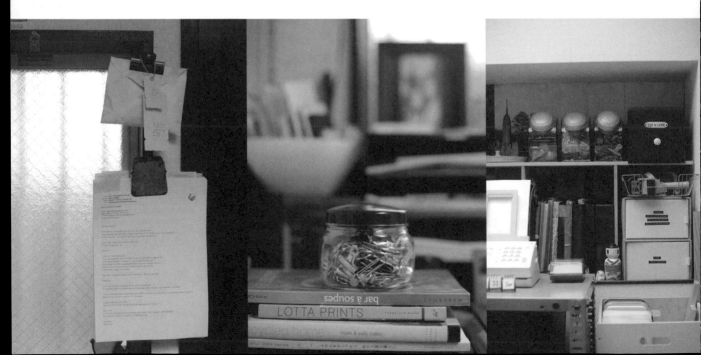

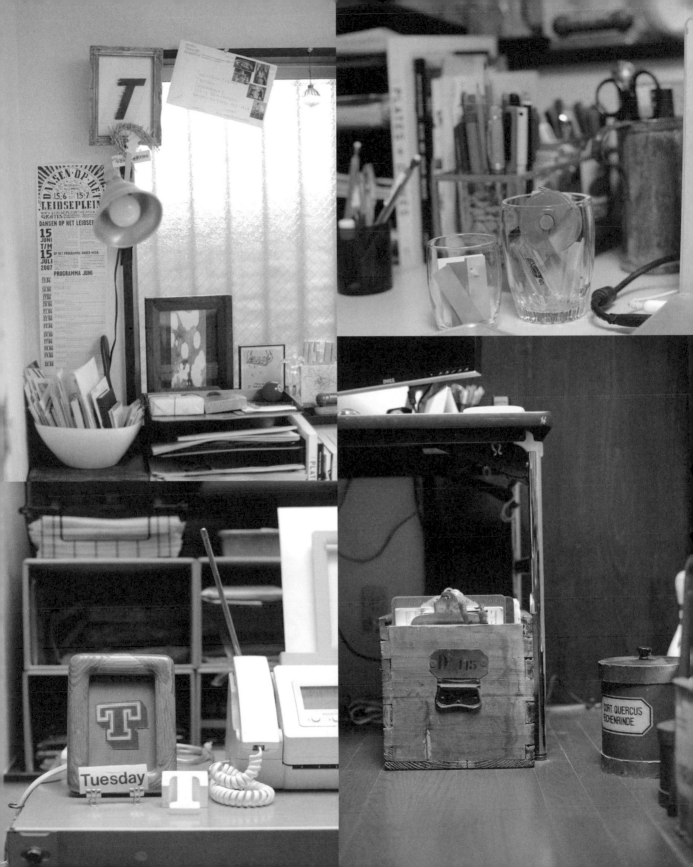

Lotta: What do you wish you could change about your studio?

Tuesday: We wish we had more space and more natural light.

Lotta: Tell me what you love about Tokyo.

Tuesday: The best thing about Tokyo is that it is a dynamic, eclectic, and diverse city. There are so many different things at our fingertips. When we walk around, we see the old and new, Japanese and other cultures, young and old, all mixed in with residences, commercial buildings, shops, schools, art galleries, parks, hills, rivers, small paths, stations, and highways. There is culture here from around the world—interior design, music, movies, wonderful food—not only from big places like the United States or Europe but also from Scandinavia, Latin America, Africa, and other Asian countries. Tokyo is also filled with kind people and good, friendly service (even at the DMV!).

Lotta: What do you enjoy most about being graphic designers?

Tuesday: As graphic designers, we get to work with many talented people in many different fields. We actually get a lot of inspiration from our clients and creative counterparts. It is an invigorating, ever-changing field that continues to stimulate us.

Lotta: When is your favorite time to work?

Tuesday: The morning is best when there is fresh light and fresh air, which equals a fresh mind. We usually plan our work and strategize in the morning, then implement the work in the evening, after the girls are asleep.

Their twins, Haru and Kei, take a juice break.

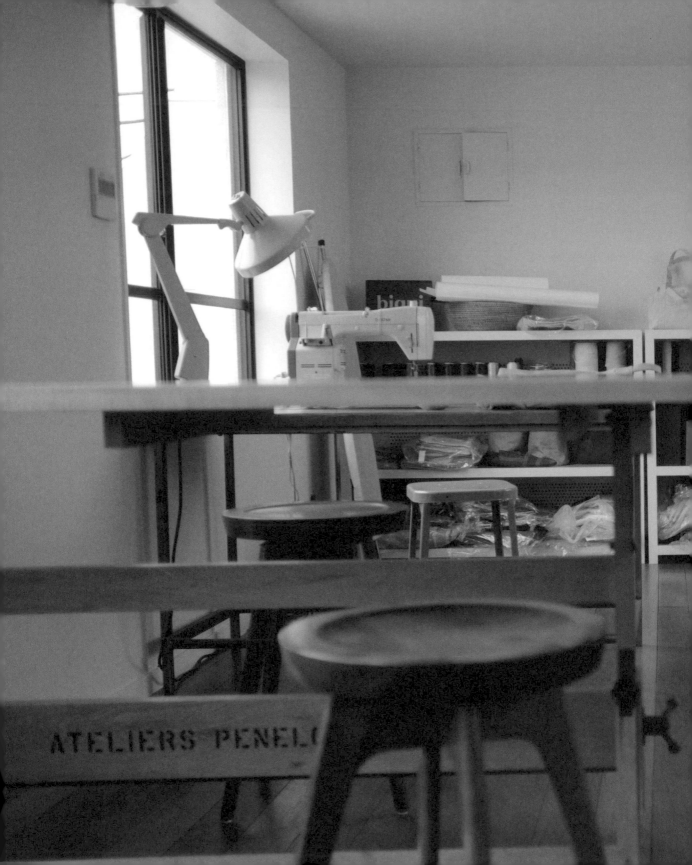

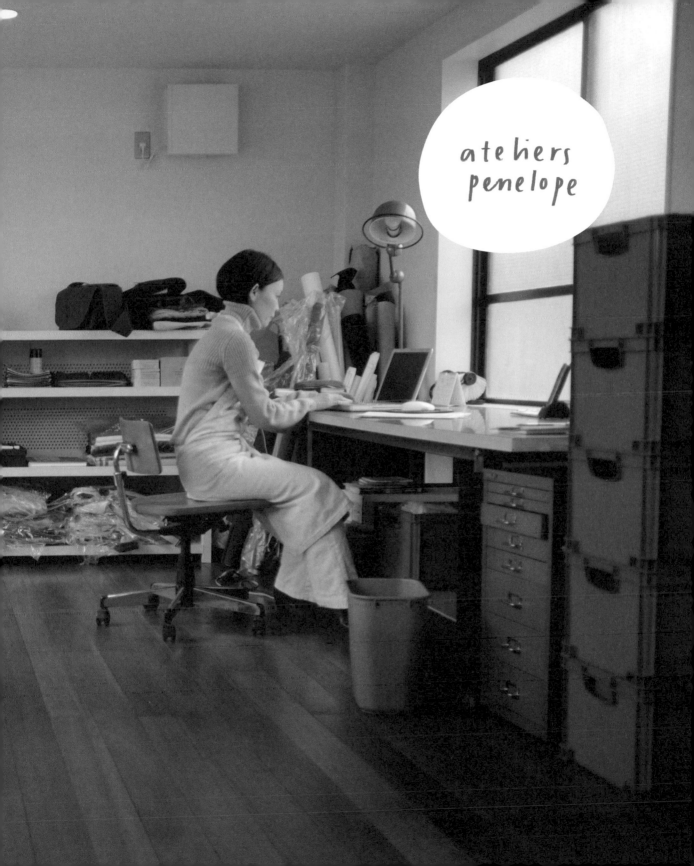

ateliers
penelope

It has been fascinating for me to watch Asuka grow and develop her company so steadily through the years. When I first discovered this bag designer back in 1999, she was located in a small basement; now her business has grown so much that it is housed in a three-level home. Here, she makes simple and sturdy totes and storage bags. What sets her bags apart from others are the vibrant colors and the fabric; she uses waxed canvas or tin cloth, which gets more water repellent as it ages. Sailors used to use this material to keep moisture at bay.

I always have to buy an Ateliers Penelope bag when I visit Tokyo. This time I ended up with a bright red one.

Asuka Karasawa

Bag designer, owner of Ateliers Penelope

Studio size: 366 square feet
(34 square meters)

Time in studio: Nine months

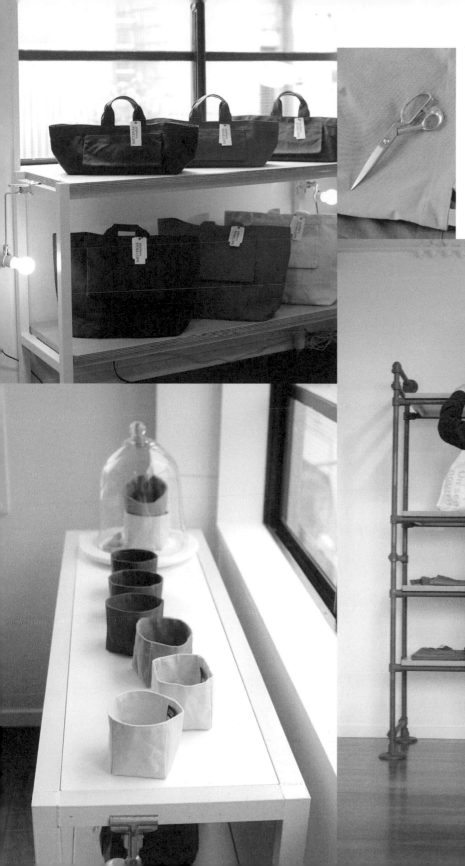

Asuka's favorite tool, naturally, is a pair of scissors.

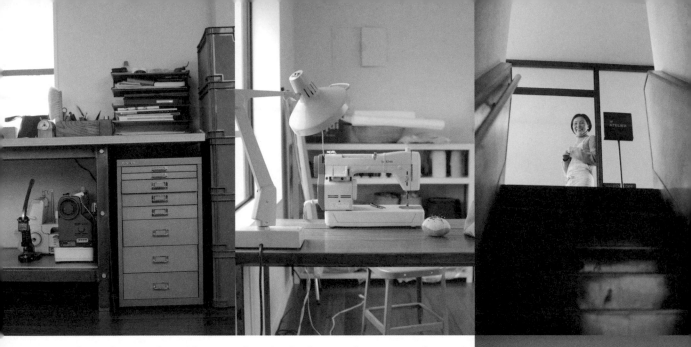

On the top floor is Asuka's studio space, where she sketches new ideas, sews samples, makes business calls, and holds meetings. She has a great view overlooking the rooftops. She is hoping to plant a rooftop garden soon!

On the ground floor (opposite page, bottom right), products are stored, assembled, packaged, and shipped. Most of the furniture was custom built to fit into this space and accommodate different needs.

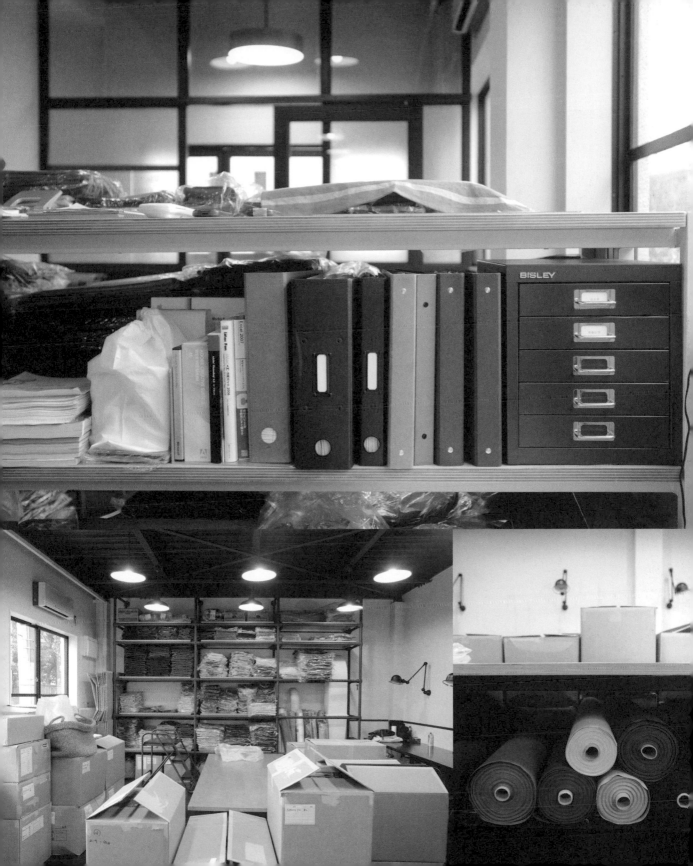

Asuka found this beautiful stor-
age unit at a yard sale and fills
it with labels, zippers, shipping
tags, and other supplies.

Lotta: Can you share a space-saving solution?

Asuka: Create storage shelving from the floor all the way to the ceiling.

Lotta: What three things inspire you?

Asuka: Memories from childhood, my parents' work running an iron factory, and
my friends who own independent businesses.

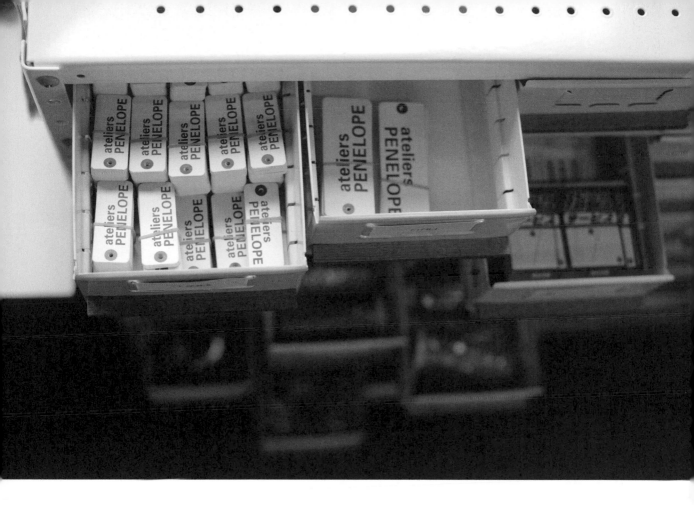

Lotta: How do you think living and working in Tokyo influences your work?

Asuka: In Tokyo, we meet many different personalities, and being with these people helps me discover more about myself. There are many different types of culture here, which enriches the senses. This stimulation leads to creativity.

Lotta: What do you like the most about your studio?

Asuka: I like the fact that it has three different levels, each for a different use. My studio is on the top floor, where I can be alone and uninterrupted, but I am still close to business activities.

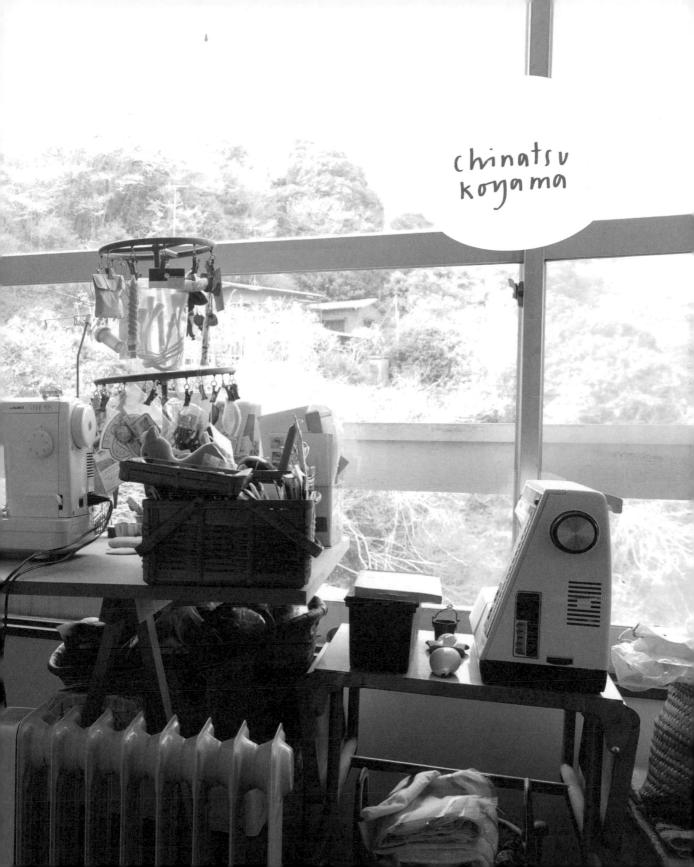

chinatsu
koyama

Jenny and I hopped into my friend Yumiko's talking Mini Cooper (the car's navigational system gives directions in Japanese) to visit Chinatsu Koyama, who lives with her young son and husband in a small house situated high up on a hill. On the top floor, she has a tiny studio, which overlooks the mountains and great big trees. It is lovely. It's hard to pin down exactly what Chinatsu creates in the space—it's a little bit of everything: she illustrates, sews, creates textile patterns, cuts, pastes, and collects things. I get the sense that Chinatsu works very spontaneously and doesn't need plans or strict concepts before starting her work. Her free and liberated approach to her work strikes me as very refreshing.

Chinatsu Koyama

Artist

Studio size: "It's maybe six to eight tatami mats!"

Time in studio: Six years

This lovely cabinet (below) opens up to become another work space.

I wondered what this round display rack (opposite page, bottom right) with clips was originally used for, but Chinatsu had no idea. Still, it's been put to good use: part organizer, part display.

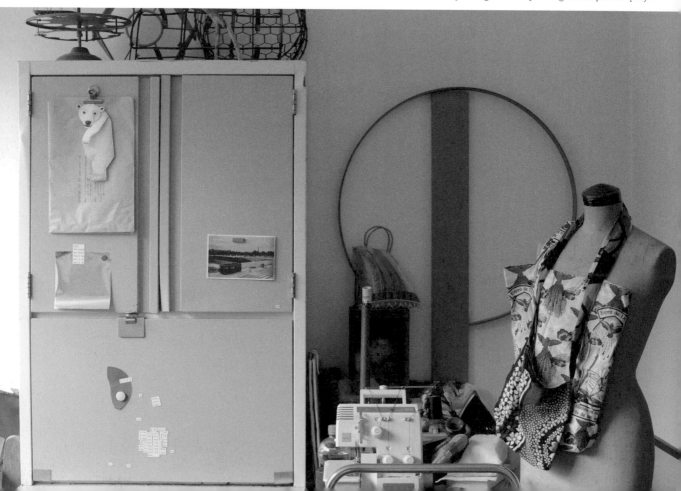

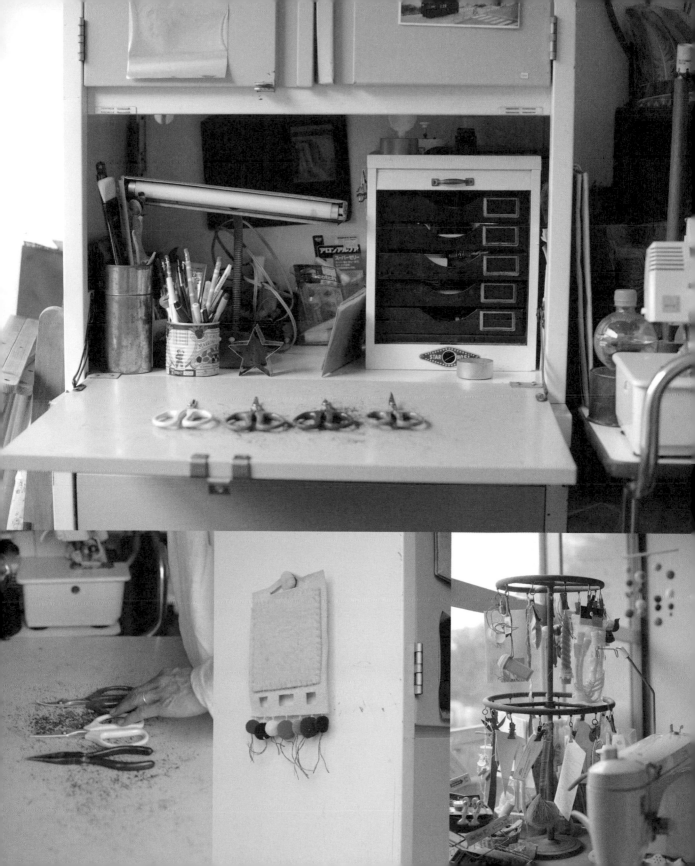

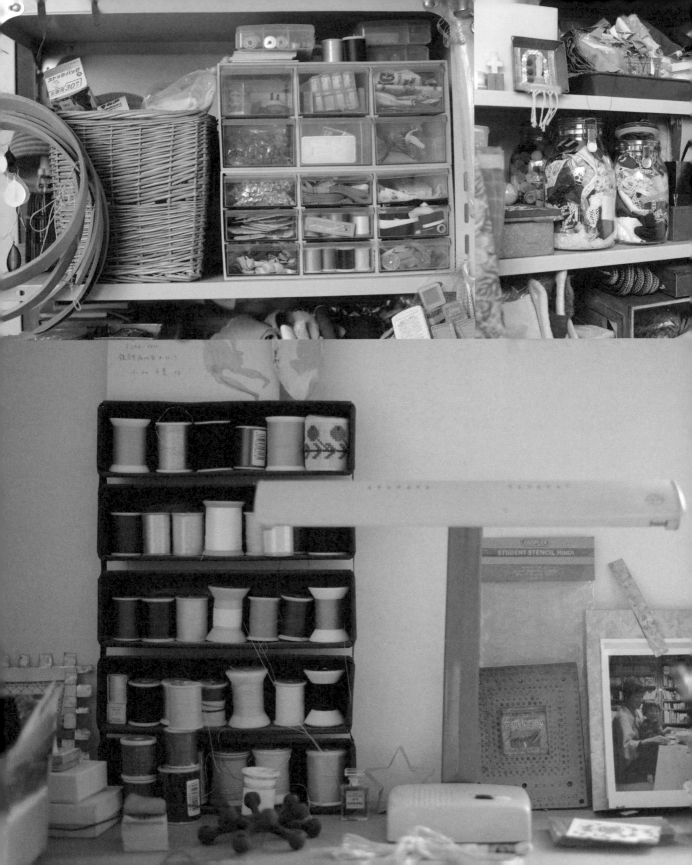

I found inspiring trinkets, supplies, and sewing notions everywhere.

Lotta: Where do you find your inspiration?

Chinatsu: It's really hard to say. By living life, walking outside . . . deadlines for an exhibition or an event also help!

Lotta: What do you like about your space?

Chinatsu: The quietness—there are almost no cars on this street.

Lotta: What do you like to listen to when you create?

Chinatsu: Honestly, I do not work to music. I listen to the sound of the wind. I listen to rain or the birds singing.

We could learn a few things from Chinatsu's art of stacking: organized stacks on the floors, the tables, and the chairs.

Chinatsu designed the patterns on these cloth pieces (below).

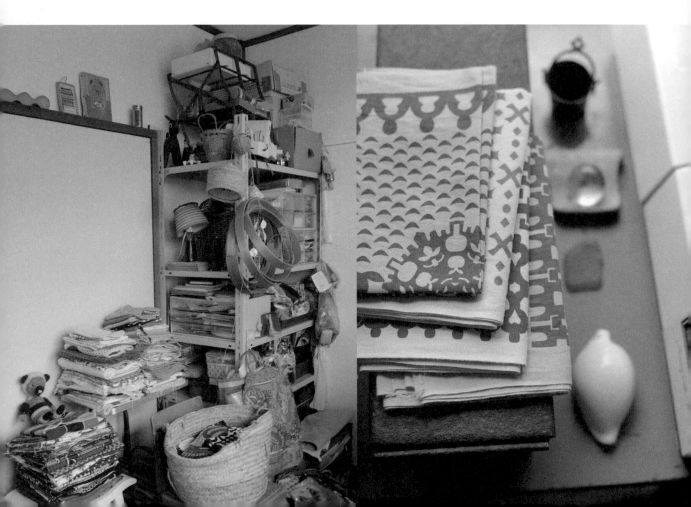

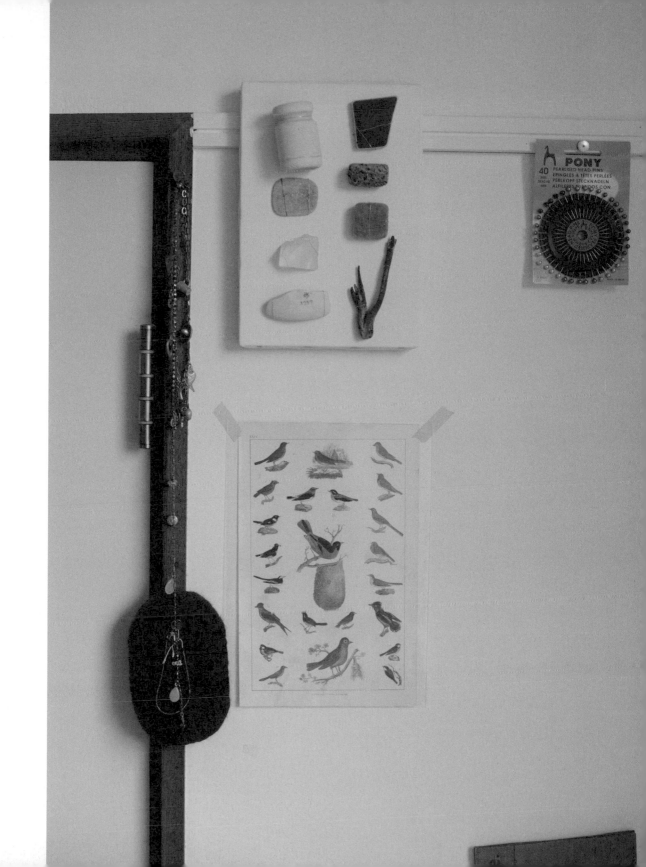

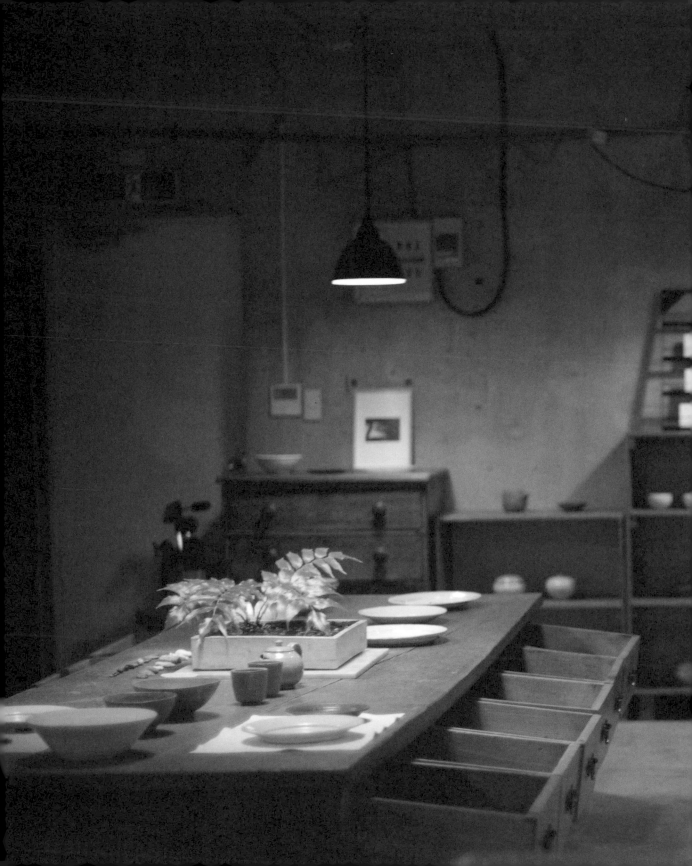

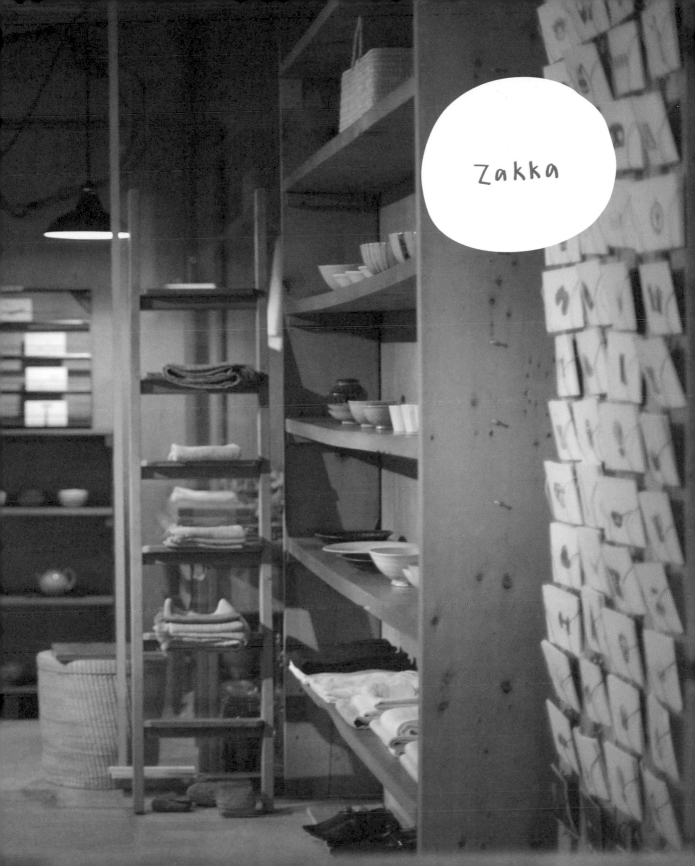

Zakka

Hitomi Yoshimura and Hiroki Kitade
Artist/makers and co-owners of Zakka
Studio size: 969 square feet
(90 square meters)
Time in studio: Twenty-three years

Zakka is a store, a gallery, a studio, a photographer's office, a café, and a working space—all in one. If you travel to Tokyo, don't miss a chance to visit the studio, owned by Hitomi Yoshimura and her husband, Hiroki Kitade. It is one of my favorite places in the world to visit. Entering Zakka is like stepping into a tranquil, creative haven. It sounds silly, I know, but everywhere you look it is so aesthetically pleasing—it makes me want to touch everything in sight.

This pair started Zakka back in 1987. While she tends the store, Ms. Yoshimura creates pot holders by mixing and matching fabrics in a patchwork style; each pot holder is unique and special. I have three of her pot holders, and I don't dare to use them; instead, they hang on my wall as art. Customers in their store are offered coffee or tea, and they can also purchase Japanese ceramic pieces and handmade cards.

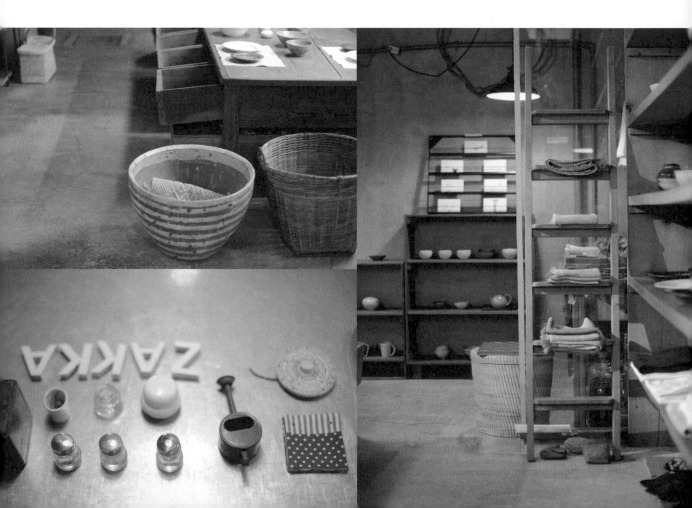

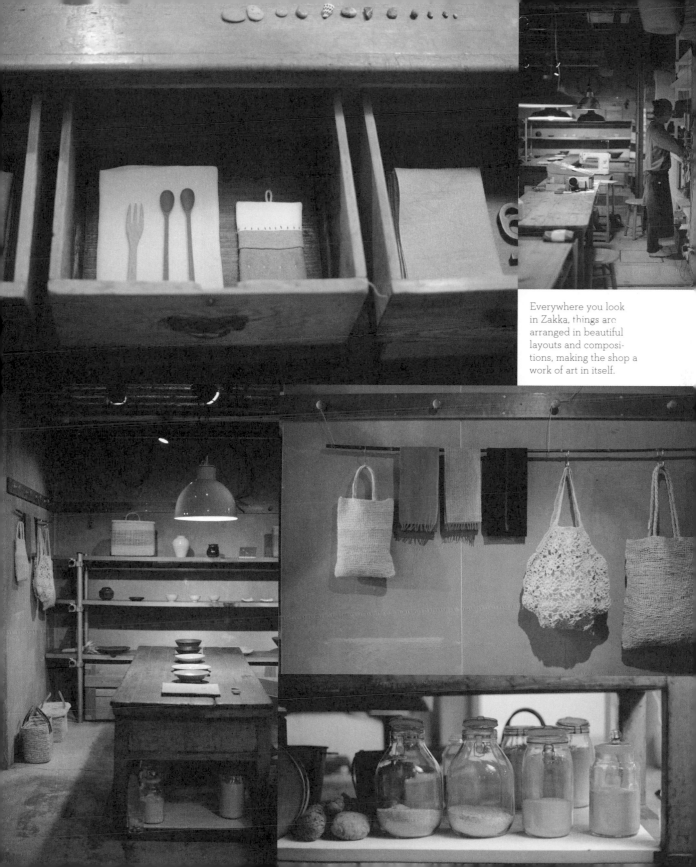

Everywhere you look in Zakka, things are arranged in beautiful layouts and compositions, making the shop a work of art in itself.

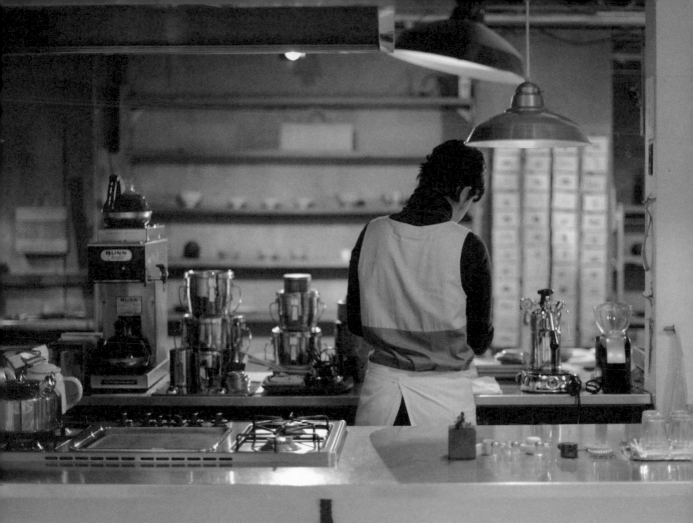

Mr. Kitade has created these rock garden calendars (left) for several years, which he sells in the shop. Simply brilliant.

In the middle of the space, separating the shop area from the exhibition area, is a long kitchen counter where they serve homemade coffee and delicious little cookies all day.

Ms. Yoshimura sits near the cash register (opposite page, top right) while she creates her one-of-a-kind textile pieces. She was working on some for an exhibition when we visited her. You can buy her pot holders only at Zakka. They usually sell out within the first couple of hours after their exhibitions have opened—a collector's item indeed.

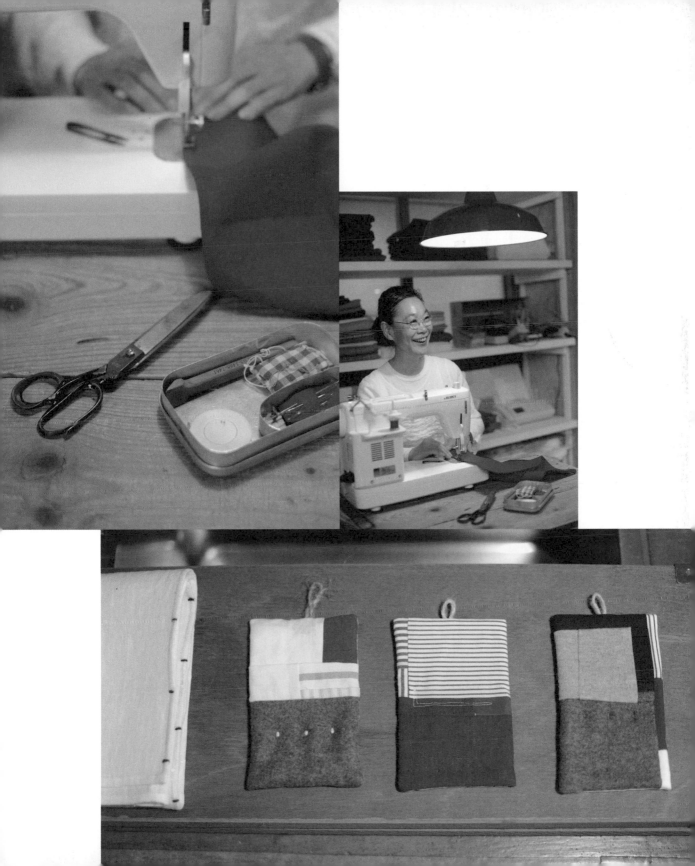

Lotta: Why did you choose this space?

Hitomi: My husband and I used to live here in this very same spot. They tore down that building and built this current one. The rent was very affordable so we opened our business here.

Lotta: Is there anything you would change in your space?

Hitomi: We actually do change the space quite often. We move the tables around and create different layouts and looks for the room.

The exhibition space has its shelving set on wheels so they can change the layout for different purposes. (I love Ms. Yoshimura's shoes!)

Lotta: How does Tokyo inspire you?

Hitomi: Tokyo is full of information and has me always wondering about what is fresh.

Lotta: What is your favorite thing about your creative space?

Hitomi: Zakka is a shop, so basically our job is selling things to the customers. I am hoping the customers who visit our store enjoy everything in our space, the products we have made, the lighting, the conversation with store staff. When I can feel that happening, it gives me energy and inspires me.

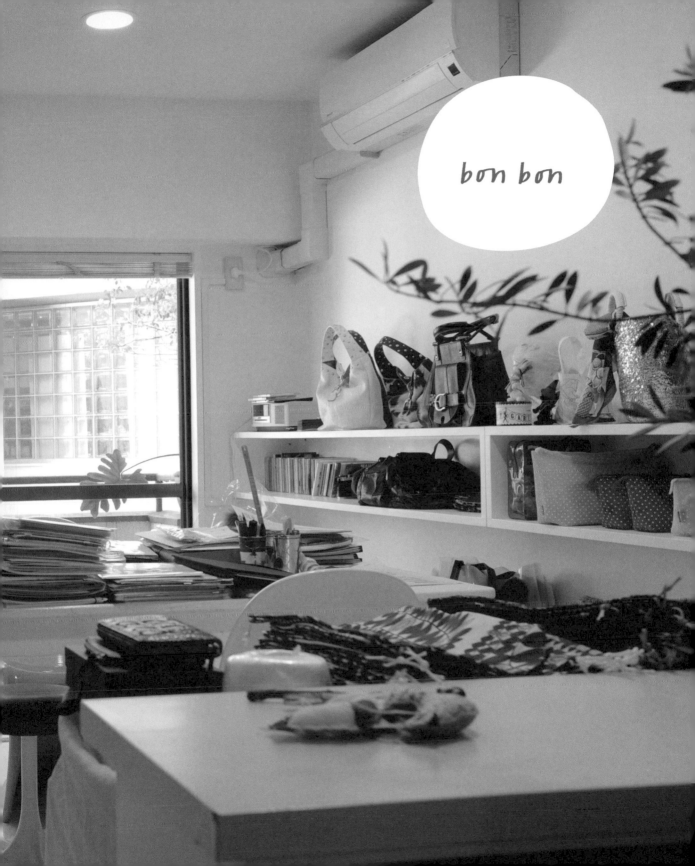

bon bon

Yuko has set up shop in a bustling Tokyo shopping district, along a quiet alleyway and behind a big department store. She runs her company, Bon Bon, from this apartment-turned-office. Here, she designs and sells bags, umbrellas, and Japanese character figures, which are very popular in Japan, especially as mobile phone accessories.

She renovated the place when she moved in. Apparently, there are no zoning laws in Japan, which gave her a lot of options. She took down a couple of walls and kept the small pantry kitchen. The place also has a nice balcony for lunch breaks.

Yuko Ibe

Owner of Bon Bon

Studio size: 323 square feet (30 square meters)

Time in studio: Four years

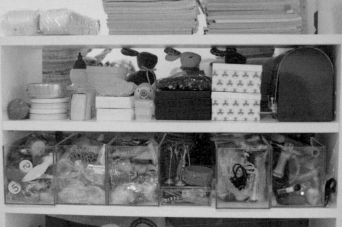

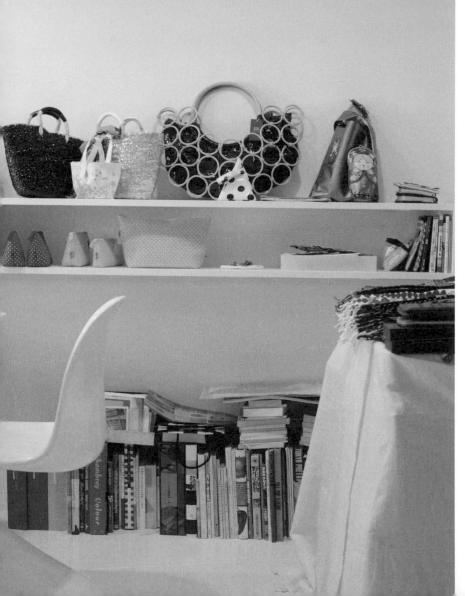

Yuko pulls inspiration from magazine clippings and photos of her trips to foreign places like Morocco.

Stand-alone shelving, filled with magazines and supplies, divides the space into two sections: the office and the showroom.

Inspirational books are lined up on the floor.

To display the products, Yuko simply covered boxes with white cloth. Here, Bon Bon bags hold other products for sale, becoming display pieces as well.

Lotta: What do you like the most about your space?

Yuko: In the summertime, I love all of the trees and leaves that surround the apartment. It is calm and quiet here, and close to everything I need.

Lotta: Where do you find inspiration?

Yuko: Material inspires me—the fabrics that I use. I am drawn to the fabrics first and from there I start creating products. Life in general inspires me.

Lotta: What do you enjoy the most about your job as a designer?

Yuko: Thinking and dreaming, and then turning those thoughts and dreams into style.

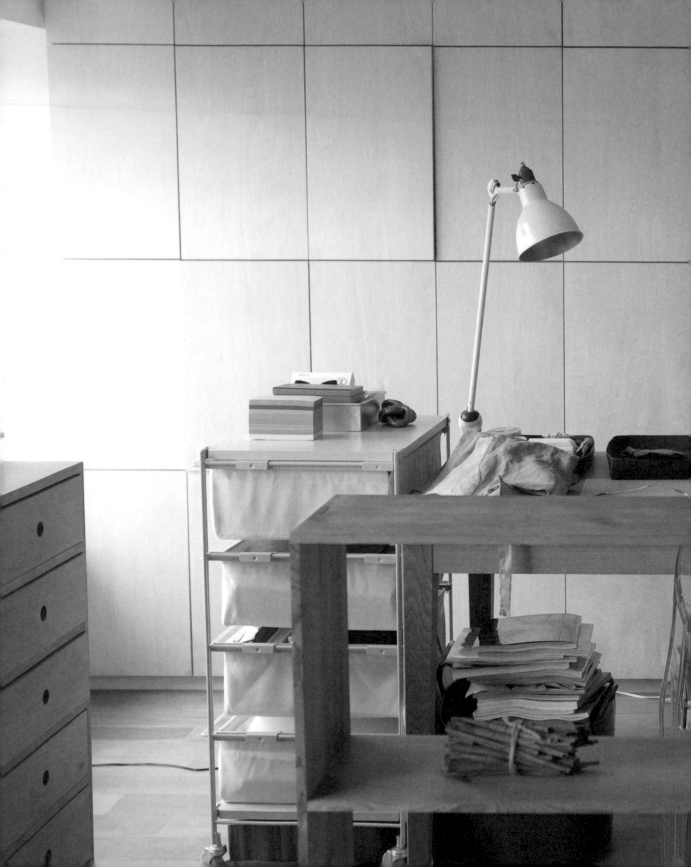

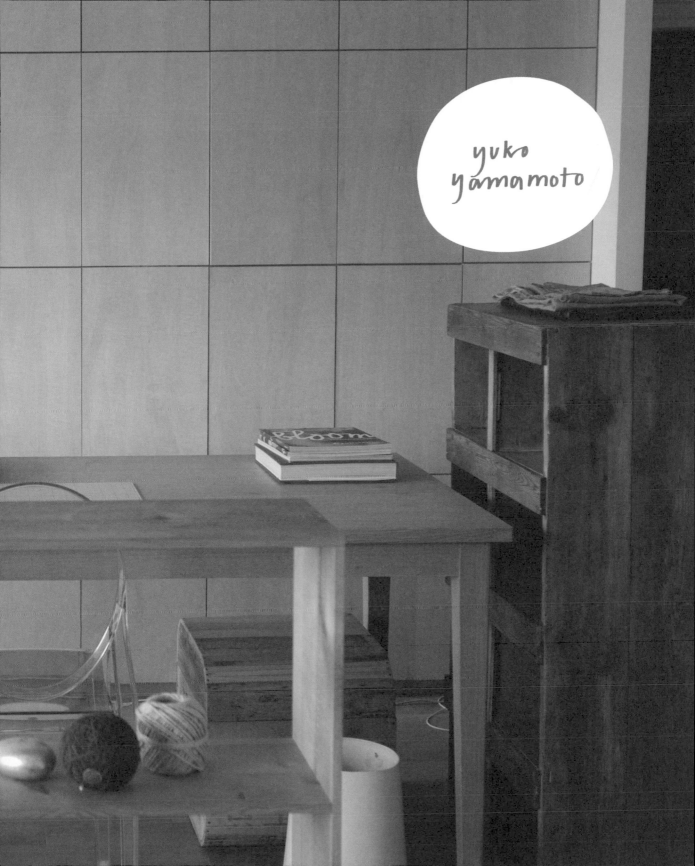

Yuko Yamamoto

Artist/designer/illustrator

Studio size: About 300 square feet
(28 square meters)

Time in studio: Three years

Yuko is an illustrator (an extraordinary one, I think). She cuts out images with extreme precision and sketches drawings with ease. She also sews images onto fabric. Her illustrations and work have been featured in many magazines, galleries, and books. Despite working out of her home, she manages a disciplined routine, working from ten in the morning to six in the evening every weekday.

Her home and studio are small and simple, but personable and charming. They are filled with antique wood pieces mixed with new, custom-built pieces. Shelving helps define space within the main room and separates her work desk from the rest of the living space. She says she finds working from home "comfortable." Close friends in the neighborhood and an excellent antique store around the corner provide a sense of community.

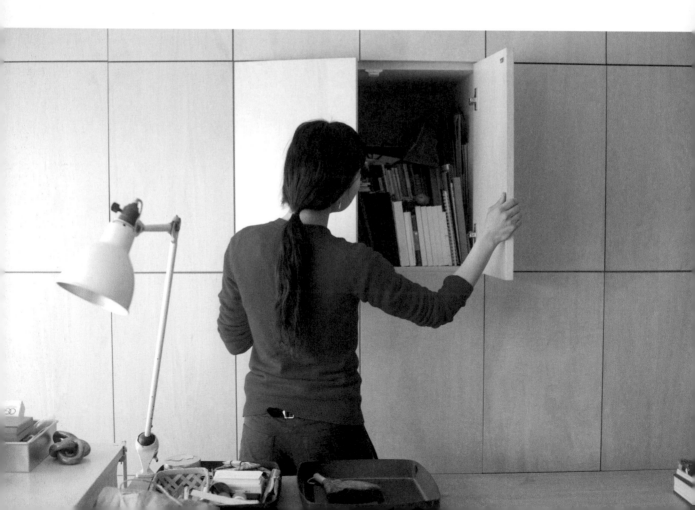

Yuko designed this wall of cupboards and picked out the wood. It's a splendid way to hide all those supplies in a clean, clever, and rather Japanese-looking way.

Natural wood shelving units (right) mark off the studio section from the rest of the apartment.

This little woven basket (below) is the cutest way of keeping track of your keys.

This wooden flat file cabinet (right) holds all of Yuko's colored papers that she uses for her illustrations. Yuko was working on this piece for an exhibition when we visited her. She hand-stitched everything, including the appliqué, and saved all the leftover fabric remnants and rolled them into balls to make beautiful necklaces (below). By the way, if you've never seen the French magazine, *Bloom: A Horti-cultural View* (upper right in photo), find one immediately. It is full of inspiring images of flowers and plants, and it shows how they relate to industries like fashion, interiors, cosmetics, food, and culture (there is also a book with earlier images from when the magazine started in 1998). It's published biannually, and, although it's on the pricey side, you won't be disappointed.

Lotta: What is your best space-saving solution?

Yuko: Cleaning. After I have done my work, I clean up.

Lotta: Is there anything you would like to improve upon in your work space?

Yuko: I need more work light. I plan to make a new lampshade.

Lotta: Where do you find inspiration?

Yuko: The everyday inspires me. It can be a cut apple, for example. I often write down and sketch my ideas.

Yuko's elegant work environment
accommodates equally elegant
Scandinavian furniture.

Dedication

There are some dear persons to whom I would like to dedicate this book:

Michael Harris, who made it possible for me to set up my first own studio.
Thank you. That support is remarkable and incredibly appreciated!

Kurt Linden, my dear uncle who always brought me bookmarks and art
supplies. You also taught me how to glue "properly," and every time I do it
I think of you there in heaven!

Jane Gregorious, for being a very important role model for me.
And for teaching me how to screen print.

Megan Fitzpatric, thank you for your passionate support through the years.

Maria Raymondsdotter, for simply being there and always listening,
through thick and thin.

Yumiko, without you none of this would ever have happened.
I am forever grateful!

Finally, I would like to acknowledge all the very creative and talented
people featured in this book. Thank you for letting us enter your life
and share it with the rest of the world!